HOW TO INSURE YOUR HOME

A Step by Step Guide to Buying the Coverage You Need at Prices You Can Afford

S0-BRP-116

THE MERRITT EDITORS

MERRITT PUBLISHING
A DIVISION OF THE MERRITT COMPANY
SANTA MONICA, CALIFORNIA

How to Insure Your Home
A Step by Step Guide to Buying the Coverage You Need at Prices You Can Afford

First edition, 1996
Copyright © 1996 by Merritt Publishing

Merritt Publishing
1661 Ninth Street
Santa Monica, California 90406

For a list of other publications or for more information from Merritt Publishing, please call (800) 638-7597. Outside the United States and in Alaska and Hawaii, please call (310) 450-7234.

Library of Congress Catalogue Number: 96-075086

The Merritt Editors
How to Insure Your Home
A Step by Step Guide to Buying the Coverage You Need at Prices You Can Afford.
Includes index.
Pages: 247

ISBN: 1-56343-132-7
Printed in the United States of America.

ACKNOWLEDGMENTS

The Merritt Editors who contributed to this book include Cynthia Davidson, Jan King, Megan Thorpe and James Walsh. Thanks also to: Kimberly Baer Design Associates, Kathie Baumoel, Cynthia Chaillie, Ginger McKelvey and Mimi Tennant.

Some forms that appear in this book are based on standard forms and information used with the permission of the Insurance Services Office.

How to Insure Your Home is the second book in Merritt Publishing's *How to Insure...* series. Upcoming titles will include *How to Insure Your Income* and *How to Insure What You Own*. Because these books are designed to make the concepts and theories of insurance understandable to ordinary consumers, the Merritt Editors welcome any feedback. Please fax us at (310) 396-4563 or call (800) 638-7597 during regular business hours, Pacific time. More information from Merritt Publishing is available on the InsWeb Internet site and at http://www.merrittpub.com.

TABLE OF CONTENTS

WHY YOU NEED HOMEOWNERS INSURANCE

Fleeing from the 1991 Oakland fires, Tobie Shapiro packed everything she could into her car and left her home to meet her husband and children on safe ground. She and her family figured they were going to lose their home—but they felt little financial threat. Their house and its contents were covered by homeowners insurance.

Or so they thought. After the fire incinerated their home, the Shapiros found that their homeowners coverage didn't cover everything they'd lost. Their insurance agent had recommended against buying **guaranteed replacement cost** coverage, which would have picked up any building costs that exceeded the policy's face value.

After the fire, contractors set the cost of rebuilding the Shapiros' home at more than $1 million—they were insured for less than $400,000.

The Shapiros weren't alone. The California Department of Insurance concluded that, of the 4,842 homes damaged or destroyed in the Oakland fire, 1,409 were underinsured.

> Under pressure from state regulators, about 30 insurance companies agreed to upgrade retroactively more than 1,000 homeowners policies in Oakland—including the Shapiros'. But you can't count on political pressure to work for you when you make a claim.

IF YOU OWN PROPERTY, YOU NEED COVERAGE

Homeowners insurance is a necessity for both **homeowners and renters.** A homeowners policy is a complete package of **personal property and liability** coverages designed to cover the average residential and personal exposures that most individuals and families encounter.

> Personal property doesn't just mean real estate. It means just about any household possession that's financially valuable—from the smallest earring to the largest refrigerator.

A policy can be issued to cover a **premises** used principally for private residential purposes (some incidental business occupancies, such as a studio or office, are permitted), and which contains **no more than two** family living units (that means single family homes and duplexes are eligible).

Separate policies are also available for **tenants of apartment buildings** and **condominium unit owners,** who only have personal **property and liability** exposures and do not need to insure the dwelling.

It is important to remember that homeowners insurance covers the **value of the home** or homes in which you live—not just the physical property. In other words, the insurance should cover risks and liabilities that might **encumber the value** of your property.

The fact that you have a $200,000 homeowners policy doesn't mean that's all you will get if your home is destroyed. The $200,000 limit usually applies only to the cost of replacing the **physical structure.** Typically, a policy will pay up to $100,000 more—half of the **face amount** of the policy—to replace the home's contents, including valuables. And it will also cover **legal costs** related to a liability lawsuit.

If you have a **separate structure** on the property—a garage, shed or guest house—that's usually covered in addition to the face amount. Your landscaping and any temporary living expenses you incur while your house is rebuilt are also covered additionally.

In other words, a homeowner with a $200,000 policy could get $200,000 to rebuild, $100,000 for personal effects, $10,000 to relandscape, $10,000 to rebuild the garage and $25,000 to cover temporary living expenses. That's a total coverage of nearly $350,000 on a $200,000 face value. And the cost of defending the homeowner in a liability lawsuit could add another $50,000 to $100,000 beyond that.

BASIC TYPES OF COVERAGE

Most insurance companies offer six basic types of homeowners-insurance policies. Every insurer may not offer all six, and the names and specific limits (named perils) of coverage may vary somewhat from company to company. In most states, these are the typical options:

- **HO-1**. The **basic** homeowners policy protects your home against **11 named perils**. This coverage is rarely enough, so many states are phasing out this type of policy.

- **HO-2**. The **broad** homeowners policy covers your home against **17 named perils**. A variation of HO-2 is available to most mobile-home owners. This type of policy generally costs 5 to 10 percent more than the HO-1 coverage.

- **HO-3**. The **special** homeowners policy protects your home against **all perils** except those specifically excluded by the contract. It typically costs 10 to 15 percent more than the HO-1 policy.

> Many companies also offer a guaranteed replacement cost policy, which goes one step further than a standard HO-3. It offers to pay the full amount needed to replace your home and its contents, even if that exceeds the policy limit. This type of policy, usually written as a form of HO-3, offers coverage similar to what was formerly called HO-5, a policy that has been phased out by most companies.

- **HO-4**. The **renters** policy generally protects the **possessions** of tenants in a house or apartment against 17 named perils. It also provides **liability** coverage but doesn't protect the actual dwelling, which should be covered under the landlord's policy. Renters who don't want to pay for liability protection can opt for a policy that covers only personal property.

- **HO-6**. The policy for **co-op and condominium owners** provides coverage for liability and personal property, much like HO-4. While insurance purchased by the co-op or condominium association covers much of the actual dwelling, individual owners who want coverage for improvements to their units must write them into an HO-6 policy. If you add a porch, for instance, you'll need an endorsement (an addition to your policy that expands its coverage).

- **HO-8**. Primarily for **older homes**, this policy covers the same perils as HO-1 but insures the house only for repair costs or its actual cash value, not its **replacement cost**. That's because the cost of rebuilding some homes with the **materials and details of the original** would make replacement cost coverage prohibitively expensive. An HO-8 policy pays to restore the damaged property, but not necessarily with the same kind or quality of materials as the original.

Throughout this book, when we cite policy language, we'll refer to the standard HO-3 or *homeowners three* policy. If you have another version, you can still use the discussion as it applies to the language that's common—which is most of the language.

COVERAGE SECTIONS AND CONDITIONS

All homeowners policies are divided into two sections:

Section One provides coverage for the insured person's **dwelling**, other **structures** on the grounds, personal **property** owned by family members, and certain types of **loss of use**, such as **rental value** or **additional living expenses**.

Section Two provides personal **liability** coverage, **medical payments** coverage, and additional coverages for claim expenses, first aid, and **damage to the property of others**.

Knowing how an insurance company defines what your **personal property** is gives you helpful information about any additional coverage that you may need to purchase.

> Personal property includes everything that is not real property; such as indoor and outdoor furniture, linens, drapes, clothing, most appliances (but not built-ins), and all other kinds of household goods and equipment used for the maintenance of the dwelling.

Unlike your house and other structures, which are insured to cover all **losses not specifically excluded**, personal property is insured on a **named perils** basis. All of the named perils are subject to exclusions—and each individual named peril may have restrictions or exclusions that apply to it.

> These technical definitions and exclusions are a major reason that you need homeowners insurance—and that you need to be careful about what kind of insurance you buy.

One individual peril that is generally accompanied by restrictions or exclusions is **fire and lightning**. There is no definition of fire in the policy, but fire is generally defined as a **product of combustion** which produces flame, light, and heat.

Fire is a major point of dispute between insurance companies and policy owners. It's defined in insurance terms as either friendly or hostile. The gas flame of a stove, a candle, or a fire in the fireplace are examples of friendly fires; however, if the gas flame ignites a pot of grease, or a candle tips over and sets fire to curtains, or an ember pops out of the fireplace and sets fire to a couch, the resulting fires are hostile.

TYPES OF OWNERSHIP

Determining the type of ownership that applies to where you live is important in deciding what type of policy and coverage you need. The different types of ownership are:

- **Fee simple.** You own the housing unit and land and are responsible for maintenance and repairs on the property. This is the most common type of ownership, typically used for single-family, detached houses.

- **Condominium.** You own your home's interior but nothing else exclusively. You share ownership of the building, land and other common areas (roof, elevators, hallways) with other owners. While most people associate condominiums with apartment-style housing, other housing styles such as townhouses and manor homes may be bought as condominiums.

- **Cooperative**. Ownership is in the form of a corporation. Owners buy a share of stock in the corporation, which gives them the privilege of occupancy. Cooperatives can be more restrictive on who moves in. Taxes are paid on the building rather than on each unit, as with the fee simple or condominium ownership types.

Within these three main types, there are a number of common sub-types.

- **Cluster or patio homes**. A group of houses similar in every way to single-family homes, except that the residents share ownership and maintenance of the land in the development—often a golf course or other recreation facility. Commonly bought as a fee simple property.

- **Townhouse**. A group of usually six buildings placed side by side with one contiguous wall between each two units. Units more often than not have at least two levels and generally include access to land that may be divided by privacy fences. Each unit has a private entrance. Commonly bought as a fee simple property or condominium.

- **Apartment flat**. A multi-story building subdivided into one-story units, with each unit usually having one owner. Apartments may include balconies. Residents share a common entrance. Commonly bought as a condominium or co-operative.

- **Quad or four-corner homes**. Four townhouse-style units with two contiguous walls. Greenways usually surround the property. Commonly bought as a fee simple property.

- **Manor house**. A four-unit building (two units downstairs, two upstairs) with one entrance and a four-car garage. Commonly bought as a condominium.

APPLYING OWNERSHIP TO A POLICY

After determining the type of ownership that applies to your home, you can then compare the needs of ownership to various policy types. In many cases, you will be able to use **endorsements** or **riders** to adapt standard policy types to specific needs.

> Endorsements and riders serve as addenda—adding coverage or conditions to standard insurance contracts.

Homeowners forms HO-1, HO-2, and HO-3 may be issued to any of the following:

- an **owner-occupant** of a dwelling,

- the **intended owner-occupant** of a dwelling in the course of construction,

- one **co-owner**, when each distinct portion of a two-family dwelling is occupied by separate co-owners,

- a **purchaser-occupant** when the seller retains title under an installment contract until payments are completed, and

- an **occupant** of a dwelling under a life estate arrangement when dwelling coverage is at least 80 percent of the current replacement cost.

> In cases where a homeowners policy is sold to a co-owner, purchaser-occupant, or an occupant under a life estate, the owner or remaining co-owner will have an insurable interest in the dwelling, other structures, premises liability, and medical payments coverage.

A co-owner's **insurable interest** can be insured by attaching an **additional insured endorsement** to the policy.

In the case of co-owners, the remaining co-owner-occupant would have to purchase a **separate policy** to cover any personal property exposure.

Mobile homes may be covered by HO-2 or HO-3 when a **mobile home endorsement** is attached to the policy. This endorsement alters certain policy provisions as necessary to provide mobile home coverage.

> To be eligible, a mobile home must be designed for year-around living and be at least 10 feet wide and at least 40 feet long.

Mobile homes may also be covered with separate, stand-alone insurance policies designed particularly for that use.

Homeowners form HO-4 can be sold to any of the following:

- a tenant non-owner of a dwelling or apartment,

- a tenant non-owner of a mobile home,

- an owner-occupant of a condominium unit,

- an owner-occupant of a dwelling or apartment when not eligible for coverage under one of the combined building and contents homeowners forms.

A homeowners policy may not be issued to cover any property to which **farm** forms or farm rates apply, or property situated on any premises used for **farming purposes**.

WHO IS AN INSURED?

A major reason that you may need homeowners insurance is that you have a family to protect from property loss or liability claims. The **definitions page** of a homeowners policy identifies the person insured by the policy (called the **named insured**) and other people insured at the request of the named insured. This portion of the policy may include the following language:

Insurance on the dwelling and any other structures is provided for the **named insured** and the insured's **spouse** if the spouse lives in the same household.

Personal property coverage and personal liability insurance are provided for the named insured and **all residents** of the same household who are **relatives of the insured**, or who are **under age 21** and in the care of any member of the insured's family.

If the named insured or the spouse dies, coverage continues for **legal representatives**. Until a legal representative is appointed, a **temporary custodian** of the named insured's property would also be covered. All **household members** who are insured at the time of the named insured's death will continue to be covered while they continue to live at the residence premises.

Upon the request of the named insured, the personal property of others may be covered while on the residence premises, and the personal property of **guests or a residence employee** may be covered while in any residence occupied by an insured.

A residence employee means an employee of any insured who performs duties related to maintenance or use of the residence premises, or who performs household, domestic, or similar duties elsewhere which are not connected to the business of any insured.

TYPES OF COVERAGE

A homeowners policy includes various coverages to reduce financial expenses or losses which could result from average residential and personal exposures that most people—and their families—encounter. These coverages provide a sort of loose checklist of exposures you may face.

- **Dwelling coverage** is the most significant coverage on all forms except HO-4 and HO-6. A policy must show a **specific amount of insurance** for the dwelling. Coverage applies to the dwelling, attached structures, and materials and supplies on or adjacent to the residence premises for use in the construction, alteration, or repair of the dwelling or other structures.

> Dwelling coverage is also sold as a separate kind of insurance. Because it doesn't cover liability or other risks, it's best used in addition to a standard homeowners policy—for second homes, vacation condos, etc. A caveat: Some state-run home insurance plans are dwelling-only coverage.

- **Coverage for other structures** applies to structures on the residence premises separated from the dwelling by a clear space, or connected only by a fence, utility line, or similar connection. The stan-

dard amount of insurance is **10 percent of the amount written for the dwelling** coverage—and it is provided as an additional amount of insurance. If 10 percent isn't enough, higher amounts of this coverage may be written for specific structures.

- **Personal property coverage** is included on all forms. The coverage is usually an additional amount of insurance equal to **50 percent of the amount written for the dwelling**. This coverage applies to personal property owned or used by any insured person while it is **anywhere in the world**. At the request of the named insured, personal property owned by others may be covered while it is on the residence premises. This limit may be increased or decreased—but not below 40 percent—by endorsement.

On forms HO-4 and HO-6, the renters' policies, personal property coverage is the major form of property insurance. The minimum amount of coverage is $6,000—and the policy may be written for any higher amount.

- All homeowners policies provide essentially the same coverage for **loss of use** of living space. If a covered property loss makes the **residence premises uninhabitable**, the policies cover—at your option—either **additional living expenses**

related to maintaining the normal standard of living of the household or the **fair rental value** of the part of the residence where you live. (If a covered property loss makes the part of your residence **rented to others** uninhabitable, the policies also cover the loss of fair rental value.)

PROPERTY AND LOSSES NOT COVERED

Homeowners insurance covers a lot—but it obviously can't cover everything you own or everything you do. Most homeowners policies also list specific property and specific kinds of losses not covered by the policy. The following types of **property and losses** are not covered by any homeowners policy—and they serve as a kind of anti-checklist:

- land, including that under an **insured residence,**

- structures used solely for **business purposes,**

- structures rented or held for rental to any person who is **not a tenant** of the insured dwelling,

- articles separately described and specifically covered by **other insurance,**

- pets (mammals, birds, or fish),

- **aircraft and parts,** other than model or hobby aircraft,

- property of **roomers, boarders, and other tenants** who are not related to any insured,

- accounts, drawings, paper records, electronic data processing tapes, wires, records, discs, or other **software media containing business data** (blank records or media are covered),

- losses caused by perils having **catastrophic potential**—these include the common water, nuclear, and war risk exclusions,

- losses caused by the common **power failure** and **ordinance or law** exclusions,

- losses caused by the **neglect** of an insured person to use all **reasonable means** to save and preserve property,

- any **intentional loss** arising out of an act committed by or at the direction of an insured,

- losses caused by, resulting from, contributed to, or aggravated by **earth movement**, and

- losses to a motor vehicle and any electronic apparatus designed to be operated solely by use of the power from the motor vehicle. (However, homeowners policies *do* cover vehicles which are not subject to motor vehicle registration and are used to service an insured person's residence or assist the handicapped.)

If you're hoping to insure any of these items or activities with homeowners coverage, you'll be out of luck. Again, the operating assumption here is that the insurance company will provide coverage against losses

that are likely to occur in a person's ordinary experience.

HOMEOWNERS VERSUS DWELLING

Many residences are insured by homeowner policies—but **stand-alone dwelling policies** are still issued for a variety of reasons. Some dwellings are ineligible for homeowners coverage because of the structure's **age, location or value.** Other dwellings are ineligible because of the number of living units involved—a homeowners policy may be used to cover one- or two-unit residential property, while dwelling forms may cover a structure containing up to four living units.

> **Dwelling policies are primarily issued to cover non-owner occupied buildings.**

Homeowners coverage is broader than stand-alone dwelling coverage in a number of important ways. The most important distinction is that **homeowners covers liability** and dwelling does not.

Unlike dwelling insurance, all homeowners insurance—even the most basic policies—includes coverage for **theft of personal property.** It even includes coverage for the loss of property from a known location when it is **likely** that the property has been stolen.

A homeowners policy will usually cover outdoor property, such as awnings and antennas—a dwelling policy does not.

Finally, coverage for **vehicle damage** is also broader. Unlike dwelling coverage, basic homeowners coverage covers vehicle damage to fences, driveways, walks, and outside lawns, shrubs, trees and plants—as long as it's not caused by someone in your household.

Like homeowners insurance, dwelling insurance comes in various forms—including **basic, named perils** (also called broad) and **all risk** (also called special).

In addition to providing broader coverage, an all risk form shifts the burden of proof from the person making a claim to the insurance company. With named peril coverage, the person making the claim has to prove that a covered peril caused the loss. With all risk coverage, the insurance company has to prove that an exclusion applied in order to deny coverage.

With some recent policy revisions, the gap between dwelling and homeowners coverages has begun to close. Personal **liability insurance** and other coverages which are associated with homeowners policies have become **options under dwelling** policies—at least in the majority of states.

CONCLUSION

This chapter has defined some of the most basic reasons that you need to have homeowners insurance. The next chapter will focus on tools you can use to determine the kind of coverage—and just how much coverage you should buy for your home.

CHAPTER 2

HOW TO FIGURE OUT HOW MUCH INSURANCE YOU NEED

If you own a home, chances are you have homeowners insurance—the **mortgage company** usually requires it. There's also a good chance you never think about your coverage, or **how much coverage** you have until your premium bill arrives. Or until a tree crashes through your living room. Or a fire barbecues your kitchen. Or a burglar absconds with the family silver.

The problem is, until it comes time to make a claim, it's hard to know whether your insurer will provide a fair and fast settlement. And, until you get a settlement, it's hard to know—for sure—whether you bought the right kind and amount of coverage.

However, there are some **guidelines** you can follow to figure out how much homeowners insurance you need.

First, your choice of which coverage and just how

much coverage to purchase will be influenced by a number of **market factors**. Even though insurance is a regulated industry, there can be a lot of difference between two insurance companies—from the way they charge premiums to the way they settle claims.

In a 1993 *Consumer Reports* questionnaire, more than 240,000 policy owners provided information about their insurance coverage, the nature of their losses, any claims problems they had, and their overall satisfaction with how their claims were handled. When readers were asked to measure overall satisfaction on a six-point scale, ranging from *completely satisfied* to *completely dissatisfied*, here's how they responded:

- Amica and United Services Automobile Association (USAA), the highest-rated homeowners insurers in an earlier study, topped the list again by completely **satisfying almost 8 out of 10 policy owners.**

- Three insurers familiar to complaints about claims handling—Travelers, Metropolitan, and Prudential—landed at the bottom of the survey, completely **satisfying less than half of the policy owners** surveyed.

- Amica and Cincinnati Insurance Company, the two insurers with the best records for promptness, each settled **more than 90 percent of its claims within one month.** Travelers, the only major insurance company with a much worse than average record for prompt payment, paid about **71 percent of its claims within one**

month. (The average company paid about 81 percent of filed claims within 30 days.)

Most of the people who answered the survey were satisfied with the amount of their final settlements. Of those who felt that they received too little, almost half said that they learned—after filing a claim—that they had less coverage than they'd thought.

IF YOU HAVE A MORTGAGE

If you have a **mortgage** on your house, the finance company will usually be included on a homeowners policy as an insured party or **co-payee.** If an insured loss occurs—but the company denies the claim because you haven't complied with some condition or requirement—payment would still be made to the mortgagee up to its **insurable interest.** This usually means the balance of whatever you owe on the mortgage.

But you should check this language closely. If you have a mortgage, you might also want to check that—or talk to someone at the mortgage company.

If the limit of your homeowners coverage is based on your mortgage, make sure that it is enough to cover the current cost of rebuilding.

To determine the **rebuilding cost,** ask an insurance agent to calculate the current cost of construction for

a house like yours or hire a professional appraiser to
do it.

In the wake of the January 1994 Northridge earth-
quake, the issue of co-payees came to a point
in southern California. Banks, insurance compa-
nies and homeowners tangled over how claims
under earthquake insurance (a special endorse-
ment to the standard homeowners policy) would
be paid. Instead of paying claims directly to
homeowners, several big insurance companies
wrote checks that named lenders as co-payees.
The banks, in turn, were reluctant to sign over
the proceeds until homeowners proved that re-
building had begun.

In a chicken-and-egg cycle, most homeowners can't
begin to rebuild until they've received money from
the insurance company. But they can't get an insur-
ance claim until rebuilding begins....

In the 1992 Alabama Supreme Court decision *Allstate
Insurance Company v. James Hilley et al.*, the issue of
rebuilding came under close scrutiny.

In July 1985, Hilley and his family bought a
homeowners policy from Allstate with coverage lim-
its of $38,000 for the dwelling and $19,000 for per-
sonal property.

In January 1986, the Hilleys' home and their personal
contents were destroyed by fire. They filed a sworn

proof of loss form and received about $14,000 for the loss of their things and $13,000 for the **actual cash value** of their house. (The check for $13,000 was made payable to the Hilleys and to the finance company holding their mortgage. After paying off the mortgage, the Hilleys had about $3,000 left.)

The Hilleys tried to borrow money to finance the rebuilding—but their applications were denied. They wrote Allstate about their inability to obtain financing. Allstate's adjuster wrote back, refusing to pay any more money **until the house had been rebuilt.**

The Hilleys then asked Allstate to **guarantee the additional money due** under the policy to a construction company that had agreed to rebuild on those terms. The adjuster wrote back, "we do not have a contract with the construction company only with the insureds."

So, the Hilleys sued Allstate. They claimed that, under terms of the homeowners policy, Allstate had promised either to rebuild the house or to pay them $38,000.

A state circuit court sided with the Hilleys and awarded them $2 million in actual and punitive damages. Allstate appealed, but the state supreme court affirmed the award. It concluded:

> Allstate's wrong consisted of falsely representing to policyholders **the extent of coverage** and concealing the necessity of obtaining financing prior to Allstate's paying [full replacement value]. [Allstate promised that,] in the event of a fire, it would rebuild the Hilleys'

house, replace their house, or pay them the $38,000....The statement was **not a promise** to act in the future. It was represented to the Hilleys as a **present fact** of Allstate's **obligations** under the insurance policy.

The court noted angrily that Allstate's senior adjuster for northern Alabama admitted he **refused full settlement** on 20 to 25 percent of all homeowners claims on similar grounds.

REPLACEMENT VALUE AND REPLACEMENT COST

You should have enough insurance to cover the cost of **rebuilding** your home. That may bear little relation to its **market value**. If the limit of your homeowners coverage is based on your mortgage, make sure that it is enough to cover the current cost of rebuilding.

A finely crafted nineteenth-century house in a run-down neighborhood could cost far **more to rebuild** than it would cost to buy.

Most insurance companies recommend that you insure your home for 100 percent of the rebuilding cost, including the foundation. Though very few homes are totally destroyed, it does happen—as victims of the 1991 fire in Oakland, California, can attest. There, some foundations melted in the 2,000-degree heat.

In most situations, you should buy insurance for **at least 80 percent of your home's replacement value.** If you buy less, you forfeit the right to collect the **full replacement value** of the insured property, even for a partial loss.

Example: If the replacement cost of your house is $100,000 and you have a fire in the kitchen that causes $10,000 in damage, you'll collect $10,000 as long as you have at least $80,000 in insurance.

Another example: You buy $100,000 of coverage—the estimated replacement cost—on your new home. A few years later, the house burns to the ground. At that time it's determined that the full replacement cost is $110,000. In order to collect this loss on the replacement cost basis, you must be carrying at least 80 percent of $110,000—$88,000. Since you've got $100,000, the loss will be settled on the replacement cost basis.

After determining rebuilding costs, you have to determine how much insurance you need.

If you're insured for less than 80 percent, the insurance company will make two estimates and pay whichever is larger.

The first estimate the insurance company will make is the **actual cash value**—this is the replacement cost minus depreciation.

> **Example:** If your $100,000 house suffers $90,000 in damage and has depreciated by 60 percent, the first estimate would be $36,000. That is figured by multiplying $90,000 by 40 percent.

The second estimate is based on the amount of insurance that you carry. This significant risk is called **implied co-insurance.**

> **Example:** If your $100,000 home is insured for $60,000, you have an insurance policy worth only three-fourths of the 80 percent replacement value. The insurance company would compute the amount of the claim by multiplying $60,000—the limit of the policy—by 75 percent to get the second estimate of $45,000. The insurance company would pay $45,000 on your $90,000 claim, the greater of the two estimates. You would be responsible for the remaining $45,000.

If you are cautious, get a homeowners policy that will pay for 100 percent of the rebuilding costs. Say you have a $100,000 home that suffers $90,000 in dam-

age. With a 100 percent replacement policy, the insurance company would pay $90,000.

If you are willing to take on some risk, buy a policy that pays 80 percent of the rebuilding costs. If your $100,000 home is insured for 80 percent, the maximum value of the policy is $80,000. So if your home suffered $90,000 in damage, the insurance company would pay $80,000.

The surest way to arrange full coverage is to buy a **guaranteed replacement cost** policy, which will pay up to 50 percent more than the face value of the policy to rebuild your home. (A few companies offer unlimited coverage.)

With a guaranteed replacement cost policy, the insurance company **automatically adjusts the amount of insurance** each year to keep up with rising construction costs in your area. The policy also protects you against the unexpected, such as a sudden increase in construction costs due to a shortage of building supplies (a problem that occurred when Hurricane Andrew ravaged Florida's Atlantic coast).

Companies that offer guaranteed coverage usually require that you insure your house for 100 percent of its replacement cost to begin with. Owners of high-risk or older homes may not be eligible for this type of policy.

KEEPING TRACK OF YOUR HOUSE AND PROPERTY

You know how much it cost to buy your house—and how much you owe on it. These numbers give you a starting point for calculating your homeowners insurance needs. But there are other ongoing factors—insurance people call them *cost drivers*—that you should consider.

Every time you make a significant **addition or improvement** to your house, you should adjust your homeowners coverage. Inflation can also creep up and leave you underinsured.

Many homeowners policies have built-in **inflation guard** clauses, which automatically increase your coverage over time. But even these policies can **misinterpret value**.

Most policies cover a structure that's detached from your house, such as a **gazebo or free standing garage**, for up to 10 percent of the total insured value of your home. To qualify as **separate**, a structure must be separated from the main house by a clear space, connected at most by a fence or utility line. Any structure that is connected by something more substantial, such as a shared roof, is not considered separate and should be figured into the total value of the house.

The things in your house can be tough to value accurately. One simple way to calculate your insurance needs is to make a list of everything you own that could generally be described as **part of your household**—including furniture (including carpets, drapes, etc.),

art or other decorations, appliances, clothes and other possessions. To organize this inventory, you can simply divide the list into relevant rooms in the house.

The chart on following pages should help.

Assigned values work best if they include relevant receipts or bills. You should also keep other support documents—including photographs or serial numbers from appliances and electronic equipment—with the inventory.

There are several ways to insure your personal property within the limits of homeowners coverage.

An **actual cash value policy** pays the amount needed to replace the item, minus depreciation. If, for instance, a fire destroyed a sofa you paid $1,000 for five years ago, you would receive only $750 for it, assuming it had a 10-year life and would cost $1,500 to replace at today's prices.

A **replacement cost** policy would pay you $1,500. For most people, replacement cost coverage on property is worth the extra 10 to 15 percent that companies typically charge for it.

Once you have an inventory, an insurance agent can help you **determine the value** of your possessions. The value of possessions will give you an idea of how much property coverage you need.

Household Property Inventory

Property	Foyer or entry area Value	Living room Property	Value	Dining room Property	Value	Kitchen Property	Value	Bedroom #1 (including closets) Property	Value	Bedroom #2 Property	Value	Other bedrooms Property	Value
Furniture													
Appliances													
Clothes													
Other													

	Bathroom #1		Bathroom #2		Other bathrooms		Den or home office		Basement		Porch or patio		Garage	
	Property	Value	Property	Value	Property	Value	Property	Value	Property	Value	Property	Value	Property	Value
Furniture														
Appliances														
Clothes														
Other														

> If you're not using an insurance agent, the insurance companies you're using—or thinking of using—should be able to provide you with historical price ranges for various kinds of personal property.

Property of **high or particular value** may not be fully insurable under standard homeowners insurance. These policies usually set limits of a few thousand dollars on things like **jewelry** or **expensive electronics**. If you own these things, you may need to buy separate insurance for them.

You can protect a particularly valuable item with a **floater**. That's an endorsement tailored to a specific item; the coverage *floats* with the property wherever it goes.

Floaters can be used to cover jewelry, furs, cameras, computer equipment, musical instruments, silverware, stamps, coins, antiques, paintings, or other valuables. They can be written either as separate policies or as **endorsements to standard policies**.

The property insured by a floater must be *scheduled*— described in terms of quantity, quality, style, manufacturer, value, and so forth. Your property inventory can come in handy in tracking this information.

In most cases, a professional appraiser's report or a bill of sale is required. Floaters can cost from a few cents to a few dollars **per $100 of coverage**, depending on the item and the crime rate in your area.

> Floaters typically exclude such risks as war, nuclear accident, wear and tear, and confiscation by the government.

You can also buy additional **blanket coverage** for a specific category of protection. For example, instead of buying a floater for an expensive wristwatch, you might want to raise your coverage in the jewelry category from $1,000 to $5,000.

> Most blanket policies, however, limit the amount you can collect for any single item. The ceiling is usually between $500 and $5,000.

CHECK OUT THE COVERAGE TERMS YOURSELF

Different homeowners policies may apply various **loss settlement terms**—including any of the ones we just considered—to different kinds of property. In other words, even if the policy offers **full replacement value** for the house, it may offer only **actual cash value** for specific kinds of property.

Here are a few examples, taken from actual policies:

> ...Personal property and structures that are not buildings (e.g., a TV antenna tower) are valued at actual cash value (replacement cost less depreciation) or the necessary cost of repair.

...Awnings, carpeting, etc., might be considered as building items but are to be valued at actual cash value and not replacement cost, which is the usual settlement basis for buildings.

You need to be careful of these sorts of shifts when you're buying homeowners insurance that you think covers full replacement value. In fact, you should be careful of promises or assurances that agents give you about policies that cover **full replacement value**. This term is used freely—but it only applies in relatively few policies.

In the 1992 case *Donald Ray Free v. Republic Insurance Co., et al.*, the California court of appeals held a shifty agent accountable for promising more than a policy could deliver.

Republic Insurance issued Free a homeowners policy in 1979. That year—and every following year until 1989—Free contacted the agent who'd sold him the policy to ask whether its **coverage limits were still adequate** to rebuild his home. Each year, he was told they were.

In 1989, a new agency took over Free's account from the one which had sold him the original policy. The new agency also told Free that the coverage limits on his property were adequate to rebuild his house.

In October 1989, Free's home was completely destroyed by fire. When he made his claim, he discovered that **property values in his area had increased substantially** in the ten years since his original policy

was issued—and that its $141,000 limit was insufficient to rebuild his home.

He sued Republic and both agencies, charging that they had a contractual **duty to provide him with accurate information** and that they breached this duty by telling him his coverage was satisfactory when they didn't actually know what it was.

The court ruled that neither the agents nor the insurance company were required under the **general duty of care** they owed Free (or any client) to advise him accurately regarding the sufficiency of his coverage limits or the **replacement value** of his residence.

The court cited another court ruling that held:

> Neither an **insurance agent** nor anyone else has the ability to accurately forecast the upper limit of any damage award....To impose such a duty...would in effect make the agent a **blanket insurer** for his principal. We fail to see where sound public policy would require the imposition of such a duty upon the agent, unless the latter has by an express agreement or a holding out undertaken that obligation.

However, the last bit of that quote applied to Free's case. He appealed the trial court's decision—and the appeals court admitted that once the agents "elected to respond to his inquiries, a special duty arose requiring them to use reasonable care." They didn't even **decline to offer an opinion**, as they could have.

Instead, they assured Free his coverage was sufficient. "Under the circumstances, defendants must be deemed to have assumed **additional duties**, which, if breached, could subject them to liability," the court concluded.

The appeals court sent the case back for a jury to consider and awarded Free the costs of the appeal. Republic settled the case, rather than taking its chances with a jury.

Even though Donald Free won his case, you should still do more than just take an agent's word for whether you have enough insurance. If the agent is wrong, he or she may be liable—but you'll probably have to suffer through years of lawsuits to get your money.

LIABILITY COVERAGE

Most homeowners decide how much insurance they need based on the cost of replacing the house and its contents in case of fire or other disaster. They often overlook whether the policy provides enough liability coverage.

The liability portion of the homeowners' policy is designed to protect assets if you are sued by someone.

Example: A salesman breaks his arm when he trips on the jagged front steps you neglected to fix. Liability insurance would pick up your legal bills and any damages a court rules that you must pay, up to the policy limit.

The last main point to consider: How much liability coverage do you need on your homeowners policy? The policy will only protect you against liabilities up to the value of the house itself—but most people use their homeowners policy as their main protection from civil lawsuits.

So, the issue of how much liability coverage you need has a lot to do with your financial condition—and the equity value in your house.

> Most homeowners policies pay up to $100,000 each time someone makes a legitimate liability claim against you. If the liability claim against you is more than $100,000, you would have to pay the difference.

Anyone can sue you—an angry neighbor, the guy who bought your '69 Plymouth, the parents of a kid on the Little League team you coach. If the person suing you wins a judgment in court, you either have to reach a **cash settlement** or face the court placing a **lien** against whatever equity you have in your house.

> The claims against you don't even have to hold up in court to hurt you financially. The cost of hiring an attorney to defend you in a civil law-suit can easily reach $10,000. This is another reason liability insurance is valuable—it covers the costs of mounting your legal defense.

So, it probably makes sense to use $100,000 as the **low end** of the liability insurance you buy. In many cases, your home may be worth more than $100,000. You can buy higher liability coverage limits—they are a **relatively inexpensive** and worthwhile additional insurance.

But, if you're going to buy more coverage, how much more should you buy?

There are several ways to **gauge the value** you should protect from liability. Some people insure against the **non-mortgaged equity** they own in a home; others insure against the **total assessed value**. The latter is the safer strategy; and it's usually available.

> If your house is worth several hundred thousand dollars, you have a large enough investment there—and probably elsewhere, too—that it needs as much coverage as you can buy at a reasonable price.

You can also buy stand-alone liability insurance separate of your homeowners policy. To protect yourself against liability claims that are greater than $100,000, you may want to buy an **umbrella liability** policy. The umbrella policy pays up to the **predetermined limit** (usually $1 million) for liability claims made against you or your family.

Even if you don't have millions of dollars invested in stocks and bonds, you probably do have some money put away in a **pension fund**. Whether this investment is an individual account—like an IRA or Keough—or a group accounts—like a traditional pension plan, 401 (k) or ESOP, it is an asset. You should protect it.

Pension benefits aren't usually exposed to legal judgments. But they have been called into question, occasionally, when calculating damages levied against someone. For this reason, you should probably include pension benefits when calculating your insurable net worth.

In order to decide whether you need high-limit liability insurance, you need to calculate your **insurable net worth**. The easiest way to calculate this number is to add up the **equity value** you have in your house, any other property you own, major personal possessions like jewelry or collectibles and any saving or liquid investments you have. The following chart should help you review these assets.

PERSONAL ASSETS INVENTORY

	market value	related debt and restrictions	net value
1. home	_____	_____	_____
2. other real estate	_____	_____	_____
3. capital investments	_____	_____	_____
4. cash savings	_____	_____	_____
5. accessible pension accounts	_____	_____	_____
6. cars, other vehicles	_____	_____	_____
7. art, other collectibles	_____	_____	_____
8. jewelry, etc.	_____	_____	_____
9. recreational equipment	_____	_____	_____
10. other items	_____	_____	_____
total	_____	_____	_____

List most recent comparable value or insured value from other coverages for market value.

> Debts and restrictions include mortgages, liens and other encumbrances on real estate property. They would also include margin loans on capital investments and liquidation costs or penalties on accessible pension funds.

> Art, jewelry and other collectibles may be covered separately. If so, you may choose to keep them out of this calculation.

The total value of all these things—even if you couldn't raise it by selling everything tomorrow—is what you need to protect.

CONCLUSION

This chapter has shown you how to calculate how much homeowners insurance you need. Before making a decision about the type of coverage you should buy, you should examine the importance of the liability portion of a homeowners policy. The next chapter of this book expands from this last topic: Why liability is such a major issue.

WHY LIABILITY IS
SUCH A MAJOR
ISSUE

Many homeowners decide how much insurance they need based strictly on the cost of replacing the house and its contents in case of fire or other disaster.

Often overlooked: Whether their homeowners' insurance provides enough **liability coverage**.

The liability portion of the homeowners policy is designed to protect assets if you are sued by someone who is injured—physically, mentally or otherwise—while on your property.

If an accident occurs on your property, anyone who is hurt can **hold you financially liable** for the injuries they suffer. Most homeowners policies offer you liability protection for bodily injury and property damage. This coverage applies to the injured person's claim and the cost of defending you if you are sued.

The standard policy's liability protection covers inju-

ries or damage caused by **you, a member of your family**, or a **pet**. It applies to injuries that occur on your property—or **anywhere in the world.**

> Most homeowners policies provide $100,000 in liability insurance, but some companies offer $200,000 or $300,000 in coverage as part of their basic policy. If your policy provides only $100,000 in liability protection, you can raise it to $300,000 inexpensively—usually for less than $20 a year.

Earlier in this century, governmental regulations prevented **property insurance** companies from selling **liability insurance**. (By the same token, liability insurance companies couldn't sell property insurance.) So, a homeowner had to purchase **two or more policies**, often from different insurance companies, to obtain total insurance protection.

Starting in the 1940s, these regulations were changed. Now, the **Homeowners Policy Program** provides liability automatically in addition to the property coverages. The combination of **two or more types of coverage** into one policy is called a **package policy.**

> By combining property and liability coverages, the insurance company is able to reduce processing costs, determine losses more accurately, and pass these savings on to the consumer in the form of lower premiums.

The liabilities covered by homeowners insurance arise from civil—not criminal—law. Criminal law deals with conflicts between an individual's behavior and the state. **Civil law** provides a means by which **one person or institution can sue another** in order to protect **private property or a right**—which one party feels has been violated by the other.

THE JARGON OF LIABILITY ISSUES

An *insured* includes the named insured, a spouse, and relatives who reside in the household, as defined on the specific policy.

In addition, an insured includes any **person or organization legally responsible for animals or watercraft** owned by an insured household member.

If the **named insured or the spouse dies**, coverage continues for legal representatives—but only with respect to the premises and property of the deceased. Until a **legal representative** is appointed, a **temporary custodian** of the named insured's property would also be covered.

All **household members** who are insured at the time of the named insured's death will continue to be covered while they continue to **live at the residence** premises.

Who's insured under the policy is an important definition. In a standard policy, the insurance company promises to pay any damages and provide legal defense for any insured. These are important benefits.

Bodily injury means harm, sickness, or disease and includes the cost of required care, loss of services, or death resulting from the injury. This is one of the main kinds of loss that constitute a civil liability.

Property damage means injury to or destruction of tangible property and includes loss of use of the property. This is another kind of loss that constitutes a civil liability.

Occurrence means an accident (including continuous or repeated exposure to conditions) which results in bodily injury or property damage neither expected nor intended by an insured person. A situation must be deemed an occurrence before insurance will apply.

TWO MAIN LIABILITY COVERAGES

There are two kinds of coverage provided under the liability section of a homeowners policy. These are identical on all homeowners policy forms—though they will appear in different locations of specific policies.

> Homeowners policies, like most kinds of insurance, organize the specific kinds of coverage they offer with a letter system—Coverage A through Coverage Z, if there are that many. But there's not much consistency beyond that. One policy's Coverage A might be the same as another policy's Coverage C, etc. When you compare policies, look for the name of the coverage in question—don't be confused by letters that don't match up.

The first liability coverage is **personal liability** coverage. This pays an injured person—usually a third party—for losses which are due to the negligence of the insured, and for which the insured is liable.

> Example: Mack takes his dog out for a walk without a leash. For no apparent reason, Mack's dog attacks Ethelbert, who happens to be jogging nearby. The attack results in injuries to Ethelbert that cost $10,000 in lost income during recovery. Mack is personally liable to Ethelbert for this $10,000.

The second liability coverage is **medical payments** to others. This covers necessary medical expenses incurred **within three years** of an accident causing bodily injury. An accident is covered only if it occurs during the policy period.

Medical expenses include reasonable charges for medical, surgical, x-ray, dental, ambulance, hospital, professional nursing, prosthetic devices and funeral services.

This coverage **does not apply** to medical expenses related to injuries of the named insured or any regular resident of the insured's household, except residence employees.

At the **insured location**, coverage applies only to people who are on the insured location **with the permission** of an insured person. Away from the insured location, coverage applies only to people who suffer bodily injury caused by:

- an insured person,
- an animal owned by or in the care of an insured,
- a residence employee in the course of employment by an insured, or
- a condition in the insured location or the ways immediately adjoining.

In some cases, these costs are simply determined; in other cases, the facts may be unclear—and the insured person may or may not be legally liable. In these cases, the insurance company will often pay medical costs as a **goodwill gesture** to avoid any legal action.

> A visitor to Mack's home slips and falls on the front steps. These injuries result in medical expenses to the visitor in the amount of $275. Later, the visitor sues Mack for $10,000, claiming damages for negligence. An insurance company will pay the $275 quickly, in hopes of preventing the larger lawsuit.

The insurance company has plenty of incentive to avoid lawsuits. Under the standard homeowners policy, it will provide a **legal defense against claims**— even if the claims are **groundless, false or fraudulent**. The company may also make any investigation or settlement deemed appropriate.

All obligations of the insurance company end when it pays damages equal to the policy limit for any one occurrence. But legal costs can add up quickly in the meantime.

Both personal liability and medical payments coverages have limits—medical payments is usually much lower than personal liability. Unless you ask otherwise, you'll get the **basic limits** of these coverages, which are the minimum amounts written. As ever, higher limits of liability can be purchased.

Personal liability insurance applies **separately to each insured person**, but total liability coverage resulting from **any one occurrence** may not exceed the limit stated in the policy.

> If Mack and his sister are both walking the dog
> when it bites Ethelbert, they both might be
> named in a lawsuit. However, their homeowners
> insurance will only cover them up to the single
> limit. If Mack was involved in one dog bite and
> his sister was involved in another, the insurance
> would cover each up to the limit separately.

ADDITIONAL COVERAGES

The personal liability coverage provides three kinds
of insurance in addition to the stated limits of liability:

- claim expenses,
- first aid to others, and
- damage to the property of others.

Claim expense coverage includes the costs of defending a claim, court costs charged against an insured person and premiums on bonds which are required in a suit defended by the insurance company.

Expenses incurred by the company, such as investigation fees, attorney's fees, witness fees, and any trial costs assessed against you will be covered by the policy.

If any bonds are required of you in the course of a lawsuit, such as release of attachment or appeal bonds, the company will pay the premium for such bonds but is under no obligation to furnish the bonds. That is your responsibility.

When the insurance company requests the **assistance of an insured person** in investigating or defending a claim, reasonable expenses of the insured—including loss of earnings up to $50 per day—are covered.

Claim expense insurance also covers **postjudgment interest** which accrues prior to actual payment. If a judgment is rendered against you, there usually is a time lapse between the rendering of the judgment and the payment of the damages awarded. The company will pay any interest charges accruing on the damage award during this time period.

Expenses for **first aid to others** are covered when the charges are incurred by an insured person—and when the charges result from bodily injury which is covered by the policy. Expenses for first aid to an insured person are not covered.

> You are authorized by the insurance company to incur expenses for first aid to an injured third party when there is bodily injury covered by the policy. It will cover your attempts to be a good Samaritan.

If **damage to the property of others** is caused by an insured person, the policy will provide replacement cost coverage on a **per occurrence limit**.

This additional coverage won't pay for:

- damage caused intentionally by an in-

sured who is at least 13 years of age (there has to be some cut-off age—otherwise, this would cover the intentional acts of insured adults);

- property owned by you, because this coverage is designed to cover property owned by others;

- property owned or rented to a tenant or a person who is resident in your household.

Example: You borrow a camera from your neighbor and accidentally drop it in your swimming pool while taking pictures. This coverage will provide up to $500 to replace the camera.

MISCELLANEOUS LIABILITY CONDITIONS

The liability coverage in a homeowners policy includes a number of other conditions, which can limit its applicability. These conditions include:

- The **bankruptcy of an insured person** does not relieve the insurance company of its obligations under the policy.

- Personal liability coverage will be treated as **excess over any other valid and collectible insurance**—unless the other insurance is written specifically to be treated as excess over the personal liability coverage.

- Your duties in the event of a covered occurrence include **providing written notice** identifying the insured person involved, your policy number, names and addresses of claimants and witnesses, and information about the time, place, and circumstances of the occurrence.

- You are also required to promptly forward every **notice, demand or summons** related to the claim and, when requested, to assist in the process of collecting evidence, obtaining the attendance of witnesses and reaching settlement.

- You are not supposed to **assume any obligations** or **make any payments** (other than first aid to others following a bodily injury), except at your own expense.

- Payment of medical costs to others is **not an admission of liability** by you. When medical payments are made, the insured person or someone acting on the behalf of the injured person has to provide written proof to support any claim. The **injured party** must submit to a physical examination, if requested by the insurance company, and authorize the company to obtain medical reports and records.

The policy will also pay up to $1,000 for your share of any **neighborhood homeowners association or condominium loss assessment** made because of bodily injury or property damage occurring on jointly owned property. Higher limits are available.

However, if a local government makes a charge against your association, your share of the loss is not covered.

> This coverage would apply if you, as a volunteer officer of the association, were sued individually.

Most homeowners policies cover business equipment and furniture in your home for up to $2,500. But they provide no coverage for business liability—which you might need if, for instance, a messenger slipped on your steps while delivering a business package.

> If you have a home office, you should consider buying additional business coverage. For about $20 to $30 a year, you can buy $5,000 in coverage for business equipment and furniture, plus $100,000 in liability coverage.

Some states allow coverage for **domestic employees** under the personal liability coverage—but this is not usually the case. Usually, a domestic must work a specified number of hours a week or reside on the premises in order for coverage to be mandatory.

Example: Your housekeeper is doing grocery shopping for your kids and slips in the store, breaking her arm. There may be coverage under your homeowners policy. If she's shopping for personal reasons when injured, there is no coverage.

EXCLUSIONS TO LIABILITY COVERAGE

There are **three major circumstances** under which liability coverage **does not apply.**

The first major circumstance: **Business activities.**

Liability assumed under a written contract is covered, as long as the contract is personal in nature. There is no coverage for business-related contracts or activities.

Personal liability coverage is not a business policy—it will only cover **personal activities** and exposures. The standard policy form itself states:

> *Any liability arising purely out of the insured's occupation or business and/or the continual or permanent rental of any premises to tenants by the insured is excluded.*

However, there are some activities which can be construed as business activities but are specifically covered under the policy as **exceptions to the exclusion.** Among these:

> ...*the insured may rent out the residence and be covered by the policy under limited circumstances....*

> ...*A portion of a residence might be used for professional purposes, such as a beauty parlor or physician's office....there is no coverage for professional liability arising out of these activities.*

The second major circumstance: **Injury to members of the insured household.**

Lawsuits between people covered by the same policy are excluded.

Before this exclusion was added to the standard policy, some courts permitted **family members** to sue other family members and collect damages.

The Utah Supreme Court considered exactly this kind of claim in its 1992 decision *Blaketta Allen v. Prudential Property and Casualty Insurance Co.*

In 1981, Allen's husband met with a Prudential agent to discuss homeowners insurance. During the meeting, Mr. Allen completed an application for a homeowners policy under which Prudential would insure the Allens' home and provide liability coverage against accidents occurring on the property.

The Allens received the policy in the mail approximately two months after the meeting. Attached to the policy was an endorsement excluding **members of the Allens' household** from liability coverage. Neither Allen nor her husband read the endorsement.

Three years after the agreement went into effect, the Allens' **two-year-old son** was seriously injured when Mrs. Allen spilled a pot of boiling water on him. After the accident, Mr. Allen contacted the Prudential agent, seeking recovery against the policy for his wife's accidental injury of his son. Based on the household exclusion, **Prudential denied coverage**.

Mrs. Allen sued, seeking to invalidate the exclusion on the grounds that the existence of the exclusion violated her reasonable expectations. The district court dismissed the lawsuit.

Mrs. Allen appealed. She argued that the household exclusion should be held unenforceable because it violated her reasonable expectations of coverage.

The Utah Supreme Court, considering this argument, classified **reasonable expectations** claims into three groups:

- construction of an **ambiguous term** in the insurance contract to satisfy the insured's reasonable expectations;

- refusal to enforce the **fine print** of an insurance contract because it limits more prominent provisions giving rise to the insured's expectations; and

- refusal to enforce an insurance **contract**

provision when it would frustrate the reasonable expectations of coverage created by the insurer outside of the contract.

The court didn't find any of these applicable to the Allens' case. The Prudential policy had stated clearly that coverage was excluded for "any Insured under...the definition of Insured." It then defined *Insured* as "residents of the Named Insured's household, his spouse, the relatives of either, and any other person under the age of twenty-one in the care of any Insured."

The exception clearly meant no medical payments coverage for the Allen's son.

> The homeowners policy is not meant to be a substitute for accident and health insurance—and this exclusion makes it clear that there is no coverage for an injury suffered by the named insured or other family members who reside in the same household.

The third major circumstance: **Intentional acts of an insured person** or acts which can be expected to produce bodily injury or property damage.

> If you mean to hurt someone, your homeowners insurance won't cover damages.

In early 1991, Ariel Hessing sought coverage under his father's homeowners insurance policies for his **former girlfriend's claims for medical costs and other damages.** Hessing had pleaded guilty to beating the woman at his father's New Jersey home in 1985. Her civil lawsuit against him was pending.

New Jersey State Superior Court Judge Burton Ironson dismissed Hessing's claim, ruling that the father's two **insurers didn't have to provide coverage** because **Hessing's act was intentional**.

"The decision sends a signal that people who lash out at their wives or girlfriends will have to personally pay and cannot transfer the responsibility to an insurance carrier," said James Rothschild, a lawyer for Pennsylvania-based Harleysville Mutual Insurance Co.

In addition to the three major exclusions, there are a number of less important circumstances in which homeowners insurance does not cover liabilities. These include the following:

- **war** or warlike action (most policies have a war risk exclusion—losses due to war are catastrophic and simply too much for insurance companies to protect against),

- rendering or failure to render **professional services,**

- transmission of a **communicable disease** by an insured,

- **sexual molestation**, corporal punishment, or physical or mental **abuse,**

- the use, sale, manufacture, delivery,

transfer or possession by any person of **controlled substances (illegal drugs)**, other than legitimate use of prescription drugs ordered by a physician,

- **entrustment** by an insured person of an excluded vehicle, watercraft, or aircraft to any person, or **vicarious parental liability** (whether or not statutorily imposed) for the actions of a minor using any of these items, and

- any loss assessment charged against the named insured as a member of an association, corporation, or community of property owners.

VEHICLE LIABILITY

One of the most dangerous activities you can undertake is driving a motorized vehicle. And the dangers posed aren't just personal—**vehicle accidents** are the most common cause of **liability claims** that most people face.

Since homeowners insurance is a major means of liability protection, a reasonably smart person might suppose that vehicle accidents and homeowners insurance come together in a lot of **liability claims**. They do. In fact, they do often.

Some people buy minimal amounts of auto insurance and hope their homeowners insurance will cover any shortfalls. Insurance doesn't work that way.

Homeowners insurance **does not apply** to any exposure—even liability—created by driving **any vehicle that is registered and tagged** with a state motor vehicle administration. There is also no coverage for liability arising out of vehicles that you **own, operate, rent or borrow.** These vehicles should be covered by an auto policy.

However, there is coverage for the **vicarious liability** created when a member of your household drives someone else's vehicle.

> **Example:** If you are sued for damage caused by your 12-year-old daughter who went joy riding with your car, there is no coverage under the homeowners policy under the vicarious liability exclusion. If she borrowed a neighbor's car, though, there would be coverage.

Liability involving the following types of **unregistered vehicle** is covered under a standard homeowners policy:

- a **trailer** which is parked in an insured premises,

- an **off-road recreational vehicle** which you rent, borrow or own—as long as it is used only at an insured location,

- damage or injuries involving **golf carts,** when used for golfing, and

- motorized **lawn mower tractors, electric**

wheelchairs and similar vehicles in dead storage are covered.

The watercraft exclusion is very similar to the motor vehicle exclusion. Larger boats are more appropriately covered by boat or yacht policies.

However, liability claims involving the following types of boats are covered:

- motorboats with inboard or inboard-outboard motors that you don't own,

- motorboats with outboard motors of greater than 25 horsepower that you have owned since before inception of the insurance contract—as long as the insurance company is notified of the exposure,

- motorboats with outboard motors of greater than 25 horsepower that you acquire during the policy period,

- sailboats that you own—as long as they are under 26 feet in length (the standard homeowners policy will cover bigger sailboats, as long as you don't own them),

- boats in storage, regardless of size.

The standard homeowners policy includes an aircraft exclusion similar to the other vehicle exclusions. A hang glider would be considered an aircraft, and would be excluded since it is designed to carry a person.

On the other hand, liability involving model planes, including remote-controlled model planes, is covered.

CONCLUSION

One of the most important reasons to purchase homeowners insurance is for liability coverage. This coverage takes shape in two parts: personal liability coverage and medical payments coverage.

> **If damage was caused by you, your spouse, children, or pets to an other person or persons on the premises of your home—you can be held liable.**

Liability coverage is one of the distinguishing characteristics of homeowners insurance. It's what separates *homeowners* coverage from *dwelling* or *fire* coverage. But liability insurance has become so important in the modern marketplace that even this distinction is fading.

> **Increasingly, liability coverage is added to dwelling and fire policies. When liability coverage is not attached to a dwelling policy directly, it's sometimes written as a separate policy.**

It is important to know the different definitions of liability and how they apply to you legally. It is also important to know when limits of liability occur in your insurance policy and the insurance company

stops paying. The next chapter will discuss not only the important definitions that apply to liability, but it will also focus on numerous definitions which are important to homeowners insurance as a whole.

IMPORTANT
DEFINITIONS

Homeowners insurance, like any other type of insurance, has its own language. Because each field has a slightly different interpretation of definitions and policies, it is important to clarify the most basic concepts and language involved within each one.

This chapter will focus on the most basic individual terms and policy language of homeowners insurance.

ATTACHED STRUCTURES

The standard homeowners policy covers not only the house on your property but also **structures attached** to it—such as an attached garage, breezeway, patio, etc.

This coverage also extends to **building materials and supplies** you're using to expand the house, build a facility like a pool or make repairs to the existing structure. This material would be covered in the event of a fire, etc.

> Example: If a garage is attached to the dwelling itself, coverage for loss to the garage is included with the dwelling coverage. However, if the garage is not attached to the dwelling, coverage for loss is part of the coverage for other structures. Most policies cover these structures for up to 10 percent of the total insured value of your home.

To qualify as **separate**, a structure must be separated from the main house by a **clear space**, connected at most by a fence or utility line. Any structure that is connected by something more substantial, such as a shared roof, is not considered separate and should be figured into the total value of the house.

BUSINESS ACTIVITIES

Business means any trade, profession or occupation. **Business activity** is any agreement, contract, transaction or other interaction that advances your occupation. These terms are important because, in most cases, homeowners policies **limit coverage** for businesses and business activities.

In a standard policy, business-related property is insured up to a few thousand dollars. Business-related liability is a more complicated issue. Liability coverage for business-related activities is strictly limited.

> Any significant business exposure should be covered under a separate commercial policy.

CIVILIAN AUTHORITY RISK

An example of **civilian authority risk**: An airplane crashes in a residential neighborhood damaging or destroying a number of dwellings, but leaving your residence undamaged. However, the entire neighborhood is sealed off by authorities while investigation of the accident and cleanup work proceed.

You and your tenants aren't allowed access to your residence for a period of five days—even though it's still in perfect condition. You could make a claim on your homeowners policy for your additional **living expenses** and the **loss of rental value**.

COLLAPSE

The dictionary definition of **collapse** is to "fall into a jumbled, unorganized, or flattened mass." Despite this simple definition, several court decisions have interpreted collapse as the "loss of structural integrity." That less exact definition causes a number of disputes.

CONCURRENT CAUSE

An example of **concurrent cause**: A hurricane causes a great deal of surface flooding in your back yard. As a result of this, the ground around your swimming pool partially gives way and your pool cracks. This is a case of a weather condition combining with an excluded peril—earth movement—to produce a loss. It is not covered.

CONSIDERATION

The most important element of a contract is the legal concept known as **consideration**—which means, simply, that one party gives something to another party in return for some thing or service.

In an insurance contract, the insured person makes a **premium payment** (consideration now) and promises to **comply with the provisions** of the policy (consideration future). In return, the insurance company promises to **pay covered claims** which occur during a stated policy period.

CONTRACT

An insurance policy is a legal **contract** or agreement between the insured and the insurance company. If anything should ever go wrong with a policy you buy, the rules of contract law will apply to a lawsuit or other action. The insurance company is one **party** to this contract, and the person buying the insurance becomes the other party. Generally, the terms of the contract require the person who buys the insurance (called the *insured*) to pay money (the *premium*) to the insurance company (the *insurer*)—and, in return, the company agrees to pay the insured for certain specified losses over the period of time the insurance is in effect.

COVERAGE

The scope of protection provided by an insurance policy is called **coverage**. The policy spells out many agreements, but perhaps most important, it specifies the type of losses for which the insured will be reim-

bursed by the insurance company. When the policy states that the insurance company will pay for a certain type of loss, then it is common to say that the insured person **has coverage** for that loss.

DEBRIS REMOVAL

Debris removal is, surprisingly, a common point of dispute between insurance companies and policy owners. When there is a fire or other type of loss of any consequence, there will be a certain amount of debris to be removed or cleaning to be done as part of the **repair operations**.

These costs are included in the claim amount as long as there is sufficient coverage to pay for the damaged property plus debris removal. If combined loss exceeds the policy limit, then an **additional amount of coverage** equal to 5 percent of the limit of liability will be made available for debris removal.

DEDUCTIBLE

In order to avoid nuisance claims, insurance companies request that most policies have a **deductible**—an initial amount an insured person must pay before the insurance company takes over. For most dwelling policies, this deductible will be at least $250 and it often is raised to $500 or $1,000 or more. The policy owner can sometimes **buy back** a lower deductible by paying a higher premium or a special one-time fee.

DUTY TO DEFEND

The insurance company has the right and the option to investigate and settle any lawsuit and claim. In the

same process, it also accepts a **duty to defend** an insured person in any related lawsuit or claim. But, once it pays the limit of its liability to settle a suit or claim, it is no longer obligated to provide any further defense.

ENDORSEMENT

Most insurance policies are printed in great quantities as **standard forms**. Since there are many variations in the protection needed by individual consumers, a means to add or delete coverages is necessary. Whenever a basic policy form is changed in any way, this change is put into effect by an **endorsement**. An endorsement often involves a premium change; you will learn how to calculate the most commonly requested changes.

ENTRUSTMENT

When an insured person rents or lends property to a non-insured person in a manner that might affect coverage, the issue of **entrustment** comes into play.

> Example: You lend your car to your brother who is not insured by your homeowners policy. If he causes an accident and you are sued, there is no coverage under the policy.

EXPIRATION

The end of the coverage period defined in the insurance policy is the **expiration** date. If the policy is not

renewed by this date, premiums and coverage both stop. However, expiration is not absolute—it does not affect payments for loss of use. If a loss occurred just before the expiration date of the policy and continued for two months after expiration, the loss would be fully covered.

EXPLOSION

Explosions can be caused by the ignition of explosive material such as natural gas or the fumes from gasoline, usually in an enclosed space or from the buildup of pressure within a container. Gas from a leaking line can be ignited by a pilot light, or fumes from cleaning clothing in an unaired room can explode.

Internal explosion means explosion occurring in a dwelling or other covered structure. It does not include breakage of water pipes or loss by explosion of steam boilers or steam pipes. This peril will provide coverage for an explosion where a fire doesn't ensue— but explosions and fires are usually closely related.

FAIR RENTAL VALUE

Fair rental value coverage applies only when the residence insured is your principal residence. If such is the case, you may elect to collect the fair rental value of your residence, instead of other valuations.

> Example: You have two extra rooms in your house which you rent out. A serious fire occurs which makes your residence uninhabitable, and the two roomers are forced to seek rooms elsewhere. As a result, you lose the income from these rentals during the two months it takes to repair the residence. The company will reimburse you for the lost rentals less any expenses associated with the rentals that do not continue, such as utilities.

FAULTINESS

If faulty planning, construction or maintenance causes a loss, the standard homeowners policy will most likely not cover these.

> An example of faulty planning: City authorities issue a building permit to a contractor who proceeds to erect a home at a site. You buy the house and insure it. After two years, you discover the walls and foundations are cracking and the house is tilting. Investigation shows the house was built on landfill improperly prepared years before. There is no coverage because of the exclusion of faulty planning.

An example of faulty construction: Because
the compacting of earth beneath a home was
not done properly, your two-year-old house
has started to sink. The walls are shifting and
cracking. There is no coverage under the stan-
dard policy for this.

An example of faulty maintenance: A county
flood canal runs behind your property. This
canal is clogged with debris which has not
been cleared out by the county. A storm hits—
and water in the canal overflows due to the
clogged debris. It floods your house. There is
no coverage under the standard policy for this.

FIRE

There is no definition of **fire** in the standard
homeowners policy, but it is a major point of dispute
between insurance companies and policy owners. Fire
can be either **friendly or hostile**. The gas flame of a
stove, a candle, or a fire in the fireplace are examples
of friendly fires; however, if the gas flame ignites a pot
of grease, or a candle tips over and sets fire to cur-
tains, or an ember pops out of the fireplace and sets
fire to a couch, the resulting fires are hostile.

In the insurance industry, there is a technical and legal definition of the term fire: a product of combustion which produces flame, light and heat.

This definition helps to determine whether damage has been caused by *fire* or other perils, such as *explosion* or *smoke*; this is important because these coverages are not always purchased together.

FORM

An insurance policy, sometimes called a **form**, is the **written statement** of a contract of insurance. Legally, a policy is a contract between the insurance company and the person buying insurance.

FREEZING

Under standard policy terms, losses resulting from **freezing** are covered while the dwelling is unoccupied as long as heat has been maintained in the building or the water supply has been shut off and the plumbing system and appliances have been drained. Losses caused by freezing while the dwelling is occupied are usually covered.

IMPLIED CO-INSURANCE

If you don't insure your home for its full assessed value, the insurance company may only pay you a comparable portion of any loss that does occur. This common practice—called **implied co-insurance**—

incentivizes homeowners to insure at least 80 percent (an industry standard threshold) of the full value of their property.

Example: If your $100,000 house is insured for only $60,000, you have only 75 percent as much insurance as the insurance industry thinks you should ($60,000 is 75 percent of $80,000). So the company would pay only 75 percent of a $10,000 claim following a small fire—that's $7,500.

INHERENT VICE

Inherent vice isn't a characteristic of Washington, D.C. It's the ability of something to destroy or damage itself without the intervention of outside help. Milk will sour in a sealed container and under refrigeration. Homeowners insurance doesn't cover such losses.

On the other hand, most losses can't be attributed to inherent vice. The rusting of metal is not inherent vice, since it is the product of a ferrous metal being exposed to air (outside help). Mechanical breakdown is related to wear and tear and would be considered a **maintenance loss**, not inherent vice.

INJURY

In the liability sections of a homeowners policy, **bodily injury** is defined as something different than personal injury. It means physical injury. The definition also

includes the resulting expenses which might occur as a result of the physical harm, sickness or death.

Personal injury includes bodily injury and also non-physical injuries like slander, libel or illegal discrimination.

INNOCENT SPOUSE DOCTRINE

Some states apply an **innocent spouse doctrine** to insurance policies. This doctrine holds that, if one spouse is not involved in and unaware of activity in which the other spouse has engaged that nullifies an insurance contract, the innocent spouse must remain insured.

Some insurance companies will write their policies to state specifically that the **misconduct of any insured bars recovery by any other insured**. Courts frequently back up the insurance companies in these disputes.

INSURABLE INTEREST

An **insurable interest** is the financial interest of a person or organization in the property who would be protected under the policy by the use of a mortgage or loss payable clause.

> **Example: If you have a $100,000 mortgage on a house appraised at $200,000, your mortgage company has an insurable interest in the insured value of your house.**

The insurable interest condition provides that the company will **not pay an amount greater than the insured's interest** in the property or the amount of coverage under the policy.

INSURED

An **insured** is a person granted coverage under the policy without actually being named. Insureds include: the named insured, spouse, relatives—especially minors—resident in the household, and others as defined by the policy. The company promises to **pay any damages and provide legal defense** for any insured.

The standard definition of insured applies to various liability coverages. It is extended to **persons or organizations** as respects animals or watercraft covered under the policy.

> Example: You lend your horse to a local service organization to pull a wagon in a Fourth of July parade. During the parade, the horse bolts and injures a spectator. This policy will cover you—as the named insured—and the service organization for any liability.

An **additional insured** is a person who is named under the policy by endorsement, usually because he or she has an insurable interest or legal liability related to the property.

> Example: You own a property jointly with someone, but you don't live on the premises. You might want to be listed as an additional insured.

INSURED LOCATION

Insured location is a sweeping definition which frequently applies to liability coverages. It includes all of the following:

- the **residence premises,**

- that part of any other premises, **other structures and grounds,** used by the named insured as a residence which is either shown in the declarations or acquired during the policy period,

- any premises used by the named insured in connection with the residence premises or a **newly-acquired premises,**

- any part of a non-owned premises where an insured person **temporarily resides,**

- **vacant land** owned by or rented to an insured person (but not farm land),

- individual or family **cemetery plots or burial vaults** of any insured person, and

- any part of a premises occasionally **rented to any insured person** for other than business use.

INTENTIONAL LOSS

The meaning of **intentional loss** is the subject of many arguments between insurance companies and policy owners. The standard homeowners policy does not cover intentional losses (insurance policies of any kind usually don't). This exclusion makes it clear that the policy is not designed to cover damage caused intentionally by an insured person. To do so would create a **moral hazard**—an incentive to cause a loss.

INTEREST (FINANCIAL)

Prejudgment interest means an additional amount of damages awarded to a plaintiff to compensate for the delay between the time of injury or damage and the time a judgment is made. Because liability claims may take months or years until an award is made, this amount is designed to replace the amount of interest the plaintiff would have earned had the damages been awarded at the time of injury or damage.

Postjudgment interest applies when a decision is made in favor of the plaintiff, but an appeal delays payment of damages. Postjudgment interest is money the plaintiff would have earned if the judgment had been paid at the time of the first judgment, before the appeal.

LIABILITY LIMIT

The **liability limit** on the policy is the maximum amount which will be paid for any **one occurrence**. (An occurrence is defined as an accident or an expo-

sure to substantially the same conditions over a period of time which causes an injury.)

The policy limit of liability is not increased because there is **more than one insured** person, nor is it increased because there is **more than one claim** or claimant as a result of a single occurrence.

LIBERALIZATION

In a standard homeowners policy, the insurance company agrees to apply automatically any changes in its standard terms that expand coverage.

Example: Shortly after you buy a homeowners policy, the special limits on certain types of personal property are broadened. For instance, the limit applying to theft of jewelry items is increased from $1,000 to $2,000. You automatically get the $2,000 limit of protection even through your policy reads $1,000.

LIMITS OF LIABILITY

Every homeowners policy—standard or customized—will include the maximum amounts that the insurance company will pay to cover various kinds of loss. These are the policy's **limits of liability.**

The limits will usually apply on a **per occurrence basis,** which means they focus on each loss—rather than how many insured persons or claimants were involved.

The limits don't necessarily describe the absolute limit of coverage provided by the policy. If several occurrences fall in a given coverage period, the policy will cover up to the limit several times.

MEDICAL PAYMENTS

Medical payments are a form of liability coverage. Paid to people injured by an insured person, they are provided with **a per person limit**—which is the maximum amount payable to one person arising out of one occurrence. There is **no limit** on the number of claims arising out of an occurrence, nor is there an aggregate limit on the amount payable.

MISREPRESENTATION

When any party to an insurance contract misstates a matter of fact, it has made a **misrepresentation**. This can be grounds for **nullification** of the policy—or damages in excess of policy limits.

Example: An applicant who has been canceled by previous carriers for excessive claims and does not show this on the application is making a material misrepresentation, since the carrier would probably not issue a policy if this information was known. In such cases, the contract could be voided by the company and any claim denied.

NAMED INSURED

A **named insured** is the person or persons whose name or names appear on the insurance policy form—such as *John Smith and Mary Smith, husband and wife as joint tenants.*

A **spouse** who is a resident in the same household is automatically a named insured, even if not named specifically. The named insured enjoys all of the protections other insured persons do—but he or she also retains certain rights and privileges, mostly having to do with changing parts of the policy.

OCCURRENCE

An **occurrence** is usually defined as an accident, or an exposure to substantially the same conditions over a period of time, which causes damage or injury.

> **Example:** Water leaking from your outside pipes softens the ground under your neighbor's garage, eventually causing a partial collapse of it. This would be considered a single occurrence.

Pay attention to the way in which occurrence is defined in any policy you sign. Insurance companies that don't want to pay homeowners claims will sometimes make tortuous arguments that whatever went wrong **doesn't qualify** as an occurrence.

PERIL

The actual cause of a loss is called a **peril**. Fire, if it causes a loss, is a peril. Insurance policies distinguish between *covered perils* (also called *perils insured against*) and *non-covered perils*.

PERSONAL PROPERTY

Personal property is property other than real property—such as furniture, linens, drapes, clothing, appliances, and all other kinds of household goods. Personal property of **guests and residence employees** may be covered at the insured's request.

In a standard homeowners policy, the insurance company will cover the personal property of any insured under the policy. By referring back to the definition of *insured*, you will see that an insured is any relative of the insured resident in the household—including persons under age 21 who are in the care of an insured.

PROPERTY DAMAGE

Property damage means injury to or destruction of tangible property and includes loss of use of the property. Note: This is broader than direct damage or destruction by a covered peril, because it also means *loss of use*.

REASONABLE REPAIRS

In the event that a loss covered by the policy causes damages in such a way as to expose property covered

by the policy to further damage, the insured is allowed to make **reasonable repairs** or to take other steps to protect that property.

RESIDENCE

Residence premises means the dwelling, other structures and grounds, or that part of any other building where the named insured lives, and which is identified as the residence premises in the declarations. In the case of a two-, three- or four-family dwelling, the named insured must reside in at least one of the family units.

In certain cases there sometimes exists a lack of clarity in determining the place of residence. If you own a **second residence**, such as a summer house or a ski lodge, it must be shown in the policy declarations at the beginning of the policy term. If you acquire the additional residence after the policy's effective date, you will be provided automatic coverage on the additional residence for the balance of the policy term.

RESIDENCE EMPLOYEE

Residence employee means an employee of any insured who performs duties related to the maintenance or use of the residence premises, including household or domestic services, or who performs similar duties. A residence employee can be a full-time employee, such as a live-in maid. It can also be a part-time employee, such as a cleaning lady who comes by once a week.

A caveat: Employees working in connection with a

home-based business are not residence employees. If you hire someone to clean your basement office, that person isn't covered under your homeowners policy.

SCHEDULED PROPERTY

Scheduled property is simply property that has been inventoried and listed.

When the value of property is not listed prior to a loss, it is called **unscheduled personal property**. This makes insurance companies nervous. On the other hand, scheduled personal property refers to property specifically described in the policy. This list of described property is referred to as the **schedule**. This makes insurance companies...well, less nervous.

Typically the types of property that will be scheduled are expensive things: jewelry, watches, furs, fine arts, silverware, sports equipment, cameras, collections and home computers. They are scheduled because of their value and the need to obtain broader coverage than is provided to unscheduled property.

SEVERABILITY

Severability of insurance means that each insured person as defined in the policy has the same rights and obligations that would exist had a separate policy been issued to each. However, this severability **does not increase the limits of liability** under the policy.

TEMPORARY LIVING ALLOWANCE

Temporary living allowance pays for extraordinary

expenses which occur when you have been displaced from your home. These expenses might include boarding a pet in a kennel, renting furniture—or paying to store furniture that survived a loss—and eating at restaurants while you're in a hotel or motel without kitchen facilities.

THEFT

The word **theft** is broadly defined as the wrongful taking of property and would include **burglary, holdup, or stealing.** You discover a television set missing from your home and no signs that the house has been burglarized. It would be presumed that this is a theft since the property could not have just been lost or misplaced. The circumstances surrounding the loss of property must be such that there can be presumption of theft.

> There's no coverage for theft of materials or supplies to be used for construction of a dwelling.

Theft by a member of your household is not covered nor is property stolen from a room you rent out. So, before you hand over the keys to your summer house to friends, check this part of your policy.

VACANT LAND

The **vacant land** coverage in a standard homeowners policy is pretty basic: If you buy five acres of land in the country and have no immediate plans to develop

it, it will be covered by the policy. This may seem inconsistent with other language that excludes coverage for the land on which you own a house—but this item relates mostly to **liability issues**.

VANDALISM

Vandalism and malicious mischief include damage done to property as a matter of spite or simply to inflict **damage without purpose**. Vandalism as a practical matter is the same as malicious mischief. But these definitions can be difficult. They are covered only under certain circumstances in a standard homeowners policy.

VICARIOUS LIABILITY

Vicarious liability is created by a minor or other dependent for whom an insured person acts as guardian. In most cases, the guardian can be held liable for the minor's behavior—even though the guardian played no direct role in the loss. Vicarious liability is a complicated insurance matter—it requires *no* direct connection.

Example: You are sued for damage caused by your 12-year-old daughter who went joy riding. If she used your car, there is no coverage under your homeowners policy; if she borrowed a neighbor's car, there would be coverage.

CONCLUSION

More definitions will occur throughout the book to provide you with more information on homeowners insurance. The object of this chapter was to tackle a few of the most basic definitions that apply to homeowners insurance coverage.

CHAPTER **5**

FIRES, FLOODS
AND EARTHQUAKES

Some perils are generally not covered—or covered sufficently—by standard homeowners insurance policies. Chief among these: **fires, floods and earthquakes.** In this chapter, we will consider how homeowners can deal with each of these disasters.

By way of illustration, we'll examine in detail the most common form of specialty fire insurance: The New York Standard Fire Policy.

But, first, some background.

The Federal Emergency Management Agency (FEMA) estimates that as many as 11 million buildings may be at risk of flooding—but only 2.6 million are currently insured against rising waters. An estimated **90 percent** of the homes damaged in the Midwestern floods of 1994 and 1995 were not insured for flood damage.

Most commercial insurance companies simply don't write flood insurance; many won't write any insurance for homes in flood plains. The easiest way for

homeowners in these areas to buy insurance is through one of several federally-administered flood insurance programs.

Homeowners who might be tempted to wait until a flood alert sounds take note: There's a five-day waiting period between the time you purchase a flood policy and when it becomes effective.

Residents of areas prone to crime, fires, and windstorms may also find insurance companies unwilling or unable to sell them policies. In many situations, agencies of the **federal or state government** operate taxpayer-subsidized insurance programs for homeowners prone to unusual risks. While this may not make sense from a budgetary perspective, it's a great deal for those who live dangerously.

So, for owners of high-risk homes, there are some options. Here are just a few:

- **Flood insurance.** The National Flood Insurance Program, administered by FEMA, offers flood insurance through the Federal Government and some 85 private insurers. To qualify, homeowners must live in one of 18,300 **flood-prone communities** that have taken specified steps to control flood damage. Rates vary according to the structure of the house and its vulnerability to flooding.

- **Windstorm insurance**. Most policies include insurance for windstorm damage. However, companies may **exclude coverage** for the peril if a house is unusually vulnerable to windstorms by virtue of its location. Seven coastal states currently administer beach- and windstorm-insurance plans to pick up where the regular policies leave off. Those states are: Alabama, Florida, Louisiana, Mississippi, North Carolina, South Carolina, and Texas.

- **High-risk policies**. Insurers may refuse to sell full replacement-cost coverage for homes they deem to be **particularly vulnerable** to fire, crime, or other perils. Unsafe wiring, unrepaired structural damage, or a history of vandalism may make a home uninsurable at some companies.

- **Earthquake insurance**. Most insurance companies offer earthquake coverage as an **endorsement on standard homeowners policies**. Premiums can run as high as 50 percent of a home's regular coverage, but rates vary according to the vulnerability of the house. Wood-frame homes, which tend to withstand quakes better than brick, cost much less to insure. Earthquake-caused damage to automobiles is not covered on an earthquake insurance policy, but it will be covered under most automobile policies.

MORE ON EARTHQUAKE COVERAGE

Homeowners insurance does not automatically cover losses caused by an earthquake—but earthquake coverage for the residence, other structures and personal property may be attached by **endorsement**.

Several earthquake-prone states—most notably California—require any insurance company that writes homeowners coverage to also write earthquake coverage. This doesn't mean these companies have to publicize earthquake coverage. Most stay quiet about it. But they have to give you information, if you ask.

Specifically, the California law mandating earthquake insurance says:

No policy of residential property insurance may be issued or delivered or, with respect to policies in effect on the effective date of this chapter, initially renewed in this state by any insurer unless the named insured is offered coverage for loss or damage caused by the peril of earthquake as provided in this chapter. That coverage may be provided in the policy of residential property insurance itself, either by specific policy provision or endorsement, or in a separate policy or certificate of insurance which specifically provides coverage for loss or damage caused by the peril of earthquake alone or in combination with other perils.

When earthquake coverage is purchased, an additional charge is made for the coverage. And **this can be expensive**—sometimes as much as the underlying basic homeowners coverage.

The type of construction of the structure is a significant factor in earthquake rates. Different rates apply to frame buildings (wood, or stucco-covered wood structures) and to those classified as masonry (brick, stone, adobe or concrete block).

> For earthquake coverage, masonry rates are usually significantly higher than frame rates. For ordinary property coverages, the reverse is true—masonry rates are lower than frame rates. This situation exists because of the nature of the exposure: wooden buildings are more vulnerable to fire than stone or brick buildings are; but stone or brick buildings are more vulnerable to earthquakes than wooden buildings are.

Because it's so expensive, earthquake insurance is usually sold with high deductibles—making it, appropriately, a **catastrophic coverage**. Anything short of major damage to your house won't be covered.

If you don't have earthquake insurance and suffer substantial losses when the Big One hits, you can claim a so-called **casualty loss** on your taxes—but only if you have unreimbursed damage in excess of 10 percent of your annual income plus $100.

> Example: If you earn $50,000 a year, you can write off damages only in excess of $5,100.

Once an area has been officially designated a **federal disaster** area in the wake of an earthquake, FEMA and other agencies make various forms of low-interest and no-interest loans available for rebuilding. Many people simply count on these subsidized loans as their earthquake insurance.

Another tax tip: When an area has been declared a disaster area, residents have the option of claiming their casualty loss on the previous or current year's tax return.

A final caveat: Earthquakes are ongoing disasters. They require some even-tempered management. If you have substantial damage to your home, including exposure to outdoor weather, your insurance company will expect you to seal it off—so rain will not cause more damage.

> If you do have earthquake coverage, you may well end up making repairs two or three times—because aftershocks can damage the repairs in process. The insurance company will usually pay for these multiple repairs, as long as aftershocks occur at least four days apart.

The best strategy for buying earthquake insurance is to take the coverage with a **deductible equal to 20 to**

50 percent of the cost of rebuilding. That will keep the premiums low—and if things get shaken up badly enough to need the coverage, you can get a cheap FEMA loan for the deductible.

This is the opposite of the best plan for flood insurance—which is, simply, **buy as much of the subsidized FEMA coverage** as the Feds will sell you.

INSURING AGAINST THE FLAMES

Flood and earthquake insurance both remain specialized enough that their terms and conditions **don't apply to most circumstances**. The one catastrophe to which everyone can relate is fire.

Here's what a standard homeowners policy does and does not cover when it comes to fire damage:

- **Structure**. The house is covered to the limits of the policy. Fire insurance covers replacement of the exact structure of your house, including the walls, roof, plumbing, wiring, wall-to-wall carpeting, molding, windows, etc.

- **Valuables**. Fine things are usually covered for a maximum of a couple of thousand dollars. If you have jewelry, furs, cameras and guns worth more, you need an insurance **rider** to cover them separately.

- **Landscaping**. Brushes and shrubs are usually covered to set limits, usually 5 percent of the structure coverage. Some

insurance companies limit this coverage
to a specific dollar amount.

- **Contents**. As we've seen elsewhere, this
coverage is usually limited to 50 percent
of the structure amount. Furniture, ap-
pliances, clothes and dishes are all cov-
ered.

- **Temporary living expenses**. Your hotel
room, rent on a house or apartment,
meals and all other extraordinary ex-
penses caused by displacement are reim-
bursable. These expenses are generally
limited by a dollar amount or time.

- **Code upgrades**. Rebuilding your house
to meet current rules and regulations is
usually not covered. If rebuilding accord-
ing to current building codes is more ex-
pensive than it would have been under
codes existing when your house was built,
you may have to pay for the upgrades.

If there are specific aspects of your homeowners policy
that you want to adjust, it's usually most cost-effec-
tive to do this with specific endorsements that raise or
change fire coverages.

THE NEW YORK STANDARD FIRE POLICY

In many circumstances, people buy fire insurance *in-
stead* of homeowners insurance. This is possible be-
cause there are enough stand-alone dwelling and fire
policies to create a separate market. This market al-
lows us to explore how the insurance industry deals
with a specific catastrophe.

Historically, the **New York Standard Fire Policy** (SFP) has been one of the most widely used fire insurance contracts. Standard provisions and exclusions from the SFP have been included in many other policy forms.

With the introduction of modern commercial property forms, the SFP has largely been replaced. Only a few states continue to require its use. However, because of its historical significance, the SFP remains a useful document—because it has influenced the language of so many property insurance policies.

> One of the unique things about the SFP is that it is the only insurance policy to have its wording standardized by law. At one time, 46 states made use of the New York Standard Fire Policy mandatory with most fire insurance contracts. Most required use of the New York form verbatim.

The SFP was **never a complete contract**. It is always issued with attachments which describe the property covered and shape the coverage. Different versions were used to insure dwellings, mercantile buildings, warehouses, and other types of property.

Endorsements were used to alter the coverage, by adding insurance against loss by **additional perils** and providing coverage for different **types of losses**.

The 1943 SFP consists of two printed pages. The **declarations and insuring agreement** are found on the

first page. The conditions and exclusions are contained in the 165 numbered lines of print found on page two.

Forms and endorsements attached to a SFP contribute to the design of the insurance contract, but the **declarations** make each policy unique. Information found in the declarations identifies a **specific risk, the parties to the contract, and insurance amounts**.

You will find space for the following information in the declarations section of the SFP:

- policy number,

- name and address of insurer,

- name and address of insured,

- name and address of agent,

- policy term (inception and expiration date),

- amount of insurance and rates and premiums for each peril covered,

- description and location of the property covered,

- itemized list of all forms and endorsements attached to the policy, and the premium charges,

- name and address of mortgagee (if any), and

- agent's signature and the signature date.

Other parts of the contract may elaborate upon and help to define entries found in the declarations. For

example, the insuring agreement states that the named insured includes the **legal representatives** of the insured. This means that, if the named insured dies or becomes incapacitated, any loss covered by the policy could be paid to the estate or to a guardian.

The insuring agreement states that the policy term begins (inception date) and ends (expiration date) at 12:01 A.M. standard time at the location of the property insured. In some states, the policies are written to begin and end at noon, standard time. In either case, pinpointing the time **to an exact minute and location** is more specific than the term stated in the declarations.

The insuring agreement also includes an **assignment clause**, which supports the concept of a personal contract. If the property is sold, **the policy may not be assigned** to the new owner "except with the written consent of the Company."

The insuring agreement of the SFP limits coverage to the property actually described in the policy. Usually, coverage applies only at the location or locations described. However, if described property is removed from the original location to protect it from the perils insured against, the policy will **automatically cover the property for five days** at another location.

Although the SFP identifies covered property, it does not define the property. This is why at least one additional form defining the type of property (such as a dwelling form) must be attached to complete the contract.

Certain kinds of personal property—including bullion or manuscripts—may be covered only if **specifically named** on the policy in writing. In other words, these special items cannot automatically be covered as part of a **general property class**, such as a building's contents or a policy owner's personal property.

The SFP excludes coverage for **accounts, bills, currency, deeds, evidences of debt, money or securities**.

> **These items are easily concealed or removed, and their value may be difficult to determine, so they are not considered to be suitable subjects for ordinary fire insurance.**

The SFP is a **named perils** contract, and it only covers the perils specified in the policy. Also, it only covers **direct losses** caused by the named perils. Direct loss means actual physical damage to, or destruction of, the insured property. In the case of removal coverage, direct loss includes the theft or disappearance of the property.

The **insuring agreement** states that the policy covers direct loss resulting from any of three causes—**fire, lightning, and removal** from premises. When a specific peril is the **proximate cause** of a loss, courts have held that the peril in question caused the loss.

Example: Loss from water damage, chemicals, firefighters breaking down a door, or smoke may be direct loss caused by fire if an uninterrupted chain of events existed between the fire and the loss.

Removal is actually a situation rather than a peril. The SFP covers direct loss "by removal from premises endangered by the perils (fire and lightning) insured against." The policy requires the insured person to make all **reasonable efforts** to save and preserve covered property at the time of loss and following a loss.

Since it would be illogical to penalize an insured person for trying to minimize a loss, the removal coverage is extremely broad—it is, in effect, **all risk** coverage. If an insured person removes covered furniture from a burning building and some of it is stolen or damaged by rain, the SFP will cover the furniture loss as a removal loss—even though the policy excludes theft and does not cover rain damage.

Whenever fire or lightning threaten covered property, removal coverage applies automatically for five days. After that time, any extension of coverage would have to be arranged with the insurance company.

Because the SFP is a named perils contract, it does not cover any perils other than those named in the insuring agreement. Various **forms and endorsements** may be added to increase the number of perils covered.

ADDITIONAL ATTACHMENTS

Because the SFP is not a complete contract, at a minimum an additional form must be attached to define the type of **property covered**. In many cases, more than one property form will be attached.

Numerous other forms and endorsements may also be attached to the SFP to alter the nature of coverage. Such attachments are usually used to accomplish one or more of the following purposes:

- to define the type of property covered,
- to cover additional types of losses,
- to increase the number of perils covered, and
- to alter the basis of recovery.

The possible combinations provided great flexibility in the formation of fire policies designed to meet a diverse range of specific needs. However, it also meant that insurers and agents had to deal with an enormous portfolio of different forms.

In recent years, a modernization program has replaced many of the older forms and has standardized many types of coverage options. As a result, the number of forms in use has been reduced drastically.

FORMS INCREASING COVERED LOSSES

The SFP and many of its attachments provide insurance against direct property losses caused by covered perils. Some types of direct loss, such as **sprinkler leakage** damage, are excluded by basic policy forms.

On the other hand, indirect losses—such as the loss of earnings resulting from business interruption—are not covered by fire insurance.

Coverage for sprinkler leakage damage and a variety of indirect losses can be provided by attachments to the SFP. Many of these coverages can also be written under separate policies.

FORMS INCREASING COVERED PERILS

Attachments which increase the number of perils insured against do not increase the amount of insurance, but merely broaden the coverage.

An **extended coverage** (commonly abbreviated as **EC**) is a package of additional covered perils which are insured as a group. It is a relatively inexpensive package and it is the most common addition to fire policies.

- **Windstorm and hail damage** to building exteriors is covered, but loss caused by frost, snow, or sleet is not covered. Damage to building interiors and contents is covered only when wind or hail first **create an opening** in the walls or roof, or cause sprinklers or pipes to leak or burst. Once wind or hail create an opening, damage caused by rain, snow, sand or dust entering the building is covered.

- **Explosion damage** is covered, including direct loss resulting from explosion of accumulated gases or unconsumed fuel within the fire box or combustion chamber of any fired vessel. Explosions within the flues or passages which conduct gases from a combustion chamber are also covered. However, the explosion peril does not cover **steam-related explosion of pipes or equipment** that the insured owns, leases, or operates, nor does it cover sonic booms, electric arcing, rupture of rotating machine parts, or bursting of water pipes.

- **Riot, riot attending a strike, and civil commotion** coverage provides riot insurance for direct physical damage. **Looting and pillage** during a riot is covered.

- **Sudden and accidental damage** from smoke is covered, but not from smoke resulting from agricultural smudging or industrial operations.

- **Aircraft damage** resulting from actual physical contact with an aircraft, or an object falling from an aircraft, is covered.

- Damage resulting from direct physical **contact with a vehicle** is covered, but vehicles owned or operated by the insured or any tenant are not covered, and damage to fences, driveways, and walks, or to any outside lawns, trees, shrubs, or plants is not covered.

> In recent years, EC provisions have been included on a number of property forms as an option, a development which often eliminates the need for a separate endorsement. Optional EC coverage is activated by showing the EC premium charge in the policy declarations.

EC on a dwelling form excludes smoke from fireplaces as well as certain agricultural and industrial sources, and excludes vehicles owned or operated by any resident instead of those owned or operated by any tenant. Under windstorm and hail coverages, both commercial and dwelling forms exclude awnings, signs, radio or television antennas and their wiring, masts, or towers.

The EC endorsement has some **general exclusions**, which eliminate coverage for war risks, nuclear risks, floods and other types of water damage. These are common exclusions, and on forms where EC perils are listed as an option these exclusions usually appear elsewhere on the form.

A **vandalism and malicious mischief** (commonly abbreviated VMM) endorsement broadens certain EC coverages and is only sold when EC has been purchased. A separate VMM endorsement may be added to the Standard Fire Policy, or the VMM section of a form which also includes EC may be activated. In either case, VMM coverage applies only when premiums for both EC and VMM are shown on the policy.

VMM covers the insured against **willful and malicious damage to or destruction of** the covered property, and that is the extent of the coverage statement. Most of the VMM endorsement is dedicated to what it does not cover:

- **glass** (other than glass building blocks) parts of a building, structure, or sign are not covered;

- **pilferage, theft, burglary or larceny** are not covered (but damage caused by burglars while entering or leaving is covered);

- **explosion of steam pipes** or steam equipment owned, leased, or operated by the insured, the rupture of moving machine parts, and losses resulting from a change in temperature or humidity, or deterioration are not covered.

The VMM coverage is suspended if a dwelling has been **vacant for more than 30 days**. *Vacant* means a building has neither occupants nor contents. (Buildings under construction are not deemed to be vacant or unoccupied.)

DEDUCTIBLES AND ENDORSEMENTS

Many of the coverage forms which may be attached to the SFP include a deductible clause. For many years, the standard deductible was $100 per occurrence, and it applied separately to:

- each building and its contents,

- the contents of each building for which there is no building coverage, and

- any personal property left out in the open.

If you want some other deductible amount to apply, an endorsement may be used to put a different deductible into effect. **Special deductible forms** can be attached to the SFP and **endorsements** may be used to alter the standard deductible found on any preprinted form.

Deductibles help to reduce insurance premiums, because they eliminate small nuisance claims and related paperwork. Standard deductibles apply to **direct loss caused by any of the insured perils**, but do not apply to indirect losses. The standard clause states that the deductible does not apply to coverage for **business interruption, tuition fees, extra expense, additional living expense, leasehold interest, rent or rental value**.

Although most fire insurance is written on an **actual cash value** basis, the SFP and other basic forms can be endorsed to provide **replacement cost** coverage. When the coverage applies, losses are settled on the basis of the actual replacement cost at the time of loss—without any deduction for **depreciation**.

> Most policies will pay replacement cost only if the property is actually repaired or replaced. If it is not, the loss will be paid on an ACV basis. The policies typically require that the policy owner maintain a minimum amount of insurance (usually 80 percent of the current replacement cost value) in order for replacement cost coverage to apply.

Local building codes may impose special requirements for newly constructed buildings. For owners of damaged older buildings, these requirements can push costs well beyond normal replacement cost. All risk forms exclude coverage for costs related to the enforcement of any law, and such additional costs are not part of the ACV or replacement cost settlement provided by fire insurance. The insured who faces the exposure can be protected by purchasing an **increased cost of construction endorsement**.

A specific amount of coverage must be purchased. Up to the coverage amount, the insurance will cover only "the increased cost of repair, rebuilding or construction" of buildings due to the "minimum requirements of any state or municipal law."

> For this coverage to apply, the old building must first be damaged or destroyed by a covered peril, the new construction must be on the same site, be for like occupancy, and be of the same height, style, and floor area.

The endorsement excludes coverage for the cost of **demolition** of any portion of the old building.

The special cost of the demolition of any part of a damaged building, in order to comply with state or municipal law, can be covered by a **demolition cost endorsement**. If a covered building is damaged or destroyed by any peril insured against, this form provides coverage for the cost of demolishing any undamaged part of the building and the cost of clearing the site. A specific amount of insurance must be purchased, and covered costs will be paid up to but not exceeding the amount stated on the form.

CONCLUSION

This chapter explored the possibilities that are available for owners of high-risk homes. It also examined in detail the New York Standard Fire Policy, which has been an influence on many standard homeowners insurance policies.

There are special options available for homeowners that live in areas that are considered for high-risk of fire, earthquakes, floods, and even windstorms. If your insurance company refuses to cover you under a broad coverage form—one of these high-risk policies may be right for your location and your home.

COVERAGE FOR CONDOS AND OTHER DWELLINGS

In some cases, your insurance needs may not be as broad as the coverages that the standard homeowners insurance package offers. You may not need liability or personal property insurance—especially if you are insuring a **second home** or **certain kinds of investment real estate**. In these situations, you may prefer to buy the more limited but less expensive **dwelling insurance**.

A common alternative to traditional home ownership—and therefore traditional homeowners insurance needs—is **condominium** ownership. Young people making their first real estate investment sometimes start with a condominium; on the other hand, many people choose to buy *condos* as second homes.

> The insurance issues that follow from owning a condominium are distinct enough that the insurance industry has created separate policies for this market.

In this chapter, we will look at the insurance policies and coverages that apply to the various other kinds of home ownership frequently available to people. We will compare these coverages to standard homeowners policies, specifically with regard to coverage issues.

CONDOMINIUMS—COLLECTIVE EXPOSURE

One of the reasons that condominiums are attractive as first investments or second homes is that they require less day-to-day maintenance than single-family homes.

> Condos usually take the shape of townhouses or—most often—apartment flats.

When you buy a condo, you buy an apartment and join a **condominium association**. The association maintains the facility—managing the sales of condo units and the upkeep of the apartment building and attached grounds.

When condominiums first became popular in the late 1960s and early 1970s, insurance companies wrote policies for condominium associations with **wide-ranging coverage** because the number of claims were few and far between. Recently, as lawsuits between condo associations and individual unit owners have become common, insurance companies define coverage **more narrowly** to reduce their exposure.

If you own—or are thinking of buying—a condominium, your primary interest should be in insuring yourself and your unit. Because condo associations make decisions by committee, they often underinsure liability and other risks.

Most condos carry **fire and casualty coverage** for the association's real property and **liability coverage** on the common areas of the condominium—as well as for their boards of directors, officers and employees.

This D&O liability is important in the event that someone—particularly any of the unit owners—sues the association for failing to perform its duties properly. However, some condo associations focus on this liability so much that they underinsure other risks.

In a condo association, there is individual responsibility or ownership for some parts of the building within the unit (such as fixtures or cabinets). The ownership and insurance responsibilities are defined in the association's **Master Deed** or **Bylaws**.

The HO-6 insurance policy form, which covers **co-op and condominium owners**, provides coverage for liability and personal property. While insurance purchased by the co-op or condominium association covers much of the actual dwelling, individual owners

who want coverage for improvements to their units must write them into a separate policy.

> **Example: If you add a porch, you'll need an endorsement (an addition to your policy that expands its coverage).**

The HO-6 form works best as a layer of **insurance above what your condo association has.** It automatically provides only a few thousand dollars of building coverage. Otherwise, the HO-6 form is very similar to the HO-4 form, which insures personal property against loss by broad form perils.

The HO-6 form takes into account the facts that:

- condominium owners own only a portion of the building in which their units are located;

- as a member of the association of unit owners, each individual unit owner has shared ownership in the building structure; and

- disputes over shared liability can result in large legal judgments against individual owners.

Often, buyers and owners of other common-interest communities, such as townhouses and cluster homes, have to depend on incorporation articles, bylaws and regulations set by their residents' association. This can leave room for a lot of problems.

For instance, if a fire started by your neighbor damaged your adjoining condo, your neighbor's insurance company might refuse to pay for your damage, claiming that your insurance should pay. The result could be that you and your neighbor, both insurance companies and a couple of attorneys would square off in court.

In most cases, to avoid these problems, condo owners buy insurance to cover the contents of their unit and condominium associations buy coverage on the real property.

Still, problems remain. One common problem is that condominium policies often don't include broad water damage coverage—for problems like sewer and drain backup. High-rise buildings also have problems with wind-driven rain—though most condo associations aren't covered for that.

Example: You buy a thirtieth-floor condo for its excellent views of the resort area where you plan to live a few months each year. You come back to the condo six months later, to find your furniture soaked and the walls covered with mildew. A series of storms, which didn't do much series damage on the ground, caused driving rain to seep through the picture windows in the units several hundred feet up. Unless your condo association has specific coverage for this rain, you may not be insured.

Claims made by underinsured condo owners are a big issue between condo associations and their insurance companies. If problems occur and the association finds it doesn't have adequate coverage for the damage, unit owners often will sue the board of the association for neglecting its fiduciary duty to protect members.

Some states require that condo associations provide **comprehensive or blanket coverage** for all members—but many states don't. Condo owners living in buildings that don't have blanket coverage against liability and property damage usually have to provide their own coverage.

The 1994 California appeals court case *Marina Green Homeowners Association v. State Farm Fire and Casualty Co.* set several precedents relating to condo insurance.

Marina Green was an association formed to manage an 18-unit condominium in San Francisco. In 1986, the association entered into a contract with State Farm for **residential property insurance** covering the condominium structure. State Farm did not offer Marina Green earthquake coverage at that time.

In January 1988, Marina Green asked State Farm's agent to renew the property insurance and to get a quote for adding **earthquake insurance** to the policy. The agent told Marina Green that State Farm would not provide earthquake coverage for the condominium.

In October 1989, the condo was severely damaged by an earthquake. The association filed a claim with State Farm for the damage. When its claim was denied,

Marina Green asked that the insurance policy be **reformed to provide earthquake coverage**.

> Reformation is a process by which an insurance policy is rewritten to add an omitted coverage retroactively. It's an unusual measure, most often happening by court order after a lawsuit.

State Farm refused, quoting California state law which held that an insurance company had **no obligation** to offer earthquake coverage "to a condominium association for a building of over four dwelling units."

Marina Green sued State Farm, alleging breach of duty to provide earthquake insurance. The trial court granted summary judgment in favor of State Farm. Marina Green appealed.

On review, the appeals court agreed with the lower court that State Farm did not have a legal duty to offer earthquake insurance. The appeals court went on to write that:

> The issue in this case is whether an insurance company owes any duty to a homeowners association, or the members thereof, to provide earthquake insurance covering a condominium structure, as opposed to the airspace comprising each individual condominium unit within that structure.

Each condominium owner in the Marina Green project was the sole **owner of a unit** and **a common owner of the structure**. Therefore, the appeals court concluded:

> In specifying that insurance be offered to cover condominium units, [the state law] on its face refers to interests in the spaces inside the condominium's structure. The further specification that insurance be offered to cover individually owned units is consistent with the differentiation between that interest which can be owned separately, i.e., units, and that interest which only can be owned jointly, i.e., the structure.
>
> It follows that...the term "policy of residential property insurance" is defined as including a policy covering the interest of an individual in the space of each unit, and presumably in the contents and fixtures, etc., within that space, but not the interest of the joint owners in the structure.

So, Marina Green's assets as a condominium association did not count as **a residence**—and State Farm did not have to make the earthquake coverage available.

DWELLING POLICIES

Alternative residential insurance needs include more than just the complex issues raised by condominium associations. In fact, the **most common variation** on homeowners coverage that most people buy is the group of coverages that insurance companies refer to as **dwelling insurance**.

This insurance applies to the **dwelling structure** that is listed in the declarations of your insurance policy—and to all of its **attached structures** on your property.

> The main distinction between dwelling insurance and homeowners insurance is that dwelling is more limited. It does not include liability coverage and—sometimes—does not include coverage for personal property.

A complete **dwelling package** will usually consist of the following coverage elements:

- a declarations page that identifies specific data, terms and conditions (must be included),

- a dwelling property coverage form (must be included),

- an optional theft coverage endorsement,

- an optional personal liability supplement (personal liability coverage and medical payments to others), and

- various other supplements or endorsements (similar to coverage options under the homeowners program).

A dwelling policy which includes **theft and personal liability coverages** is very similar to a standard homeowners policy. Many of the coverages and the basic limits of insurance are identical. However, the appeal of the dwelling package is that it provides the flexibility to **include only property coverage.**

Dwelling policy forms filed by the Insurance Services Office (ISO) are in use in nearly every state. Standard forms are generally issued and endorsements are used to adjust the coverage where required by law.

WHO IS INSURED?

Just as in a homeowners policy, an important part of the dwelling policy is distinguishing **who is—and is not—covered** under the policy. Generally, because the dwelling package doesn't include liability coverage, its coverage extends to fewer people.

Insurance on the dwelling and any other structures is provided for the **named insured**, and for the named insured's spouse if a resident of the same household.

If personal property is insured, the named insured and **all members of his or her family** residing at the described location are covered for property which they own or use. The personal property of guests and servants may be covered at the request of the named insured.

If the named insured dies, coverage continues for his or her legal representatives. Until a legal representative is appointed, a temporary custodian of the estate would also be covered.

THREE DWELLING FORMS

Three dwelling property **forms** are available. The different forms provide different degrees of coverage, and

the names given to the forms reflect a progressive expansion of both the perils and losses covered. The three forms are:

- the **basic** form—which insures against the perils of fire, lightning, and (limited forms of) internal explosion (a package of optional coverages can be added for an additional premium);

- the **broad** form—which insures all of the standard and optional perils available on the basic form and expands several of those; and

- the **special** form—which insures against any risks which are not excluded.

> Many insurance companies offer the same three-level variation in their homeowners policies. The basic form—which may not be the first policy the insurance company offers—will usually cost 20 to 30 percent less than the others.

Dwelling forms include other conditions which are common to property insurance coverages. All three dwelling forms have provisions regarding **abandonment, appraisal, assignment, concealment or fraud, legal action, insurer's option to repair or replace, insured's duties in the event of loss, waivers, mortgagee and subrogation** clauses which are similar to those found on other personal and commercial property insurance forms.

If you buy the **basic form**, you can—and probably should—purchase the **extended coverage** (EC) and **vandalism or malicious mischief** (VMM) supplements.

The EC package covers damage caused by:

- **windstorm or hail** (interior damage covered only if wind or hail first makes an opening);

- **explosion** (a slightly broader term than *internal explosion*);

- **riot or civil commotion**;

- **aircraft**, including self-propelled missiles and spacecraft;

- **vehicles** (not including vehicle damage to fences, driveways and walks or damage caused by any vehicle owned or operated by the named insured or any household member);

- **smoke**, meaning **sudden and accidental** damage from smoke (but not smoke from fireplaces or from agricultural smudging or industrial operations); and

- **volcanic eruption** other than loss caused by earthquake, land shock waves or tremors.

VMM may be purchased only if EC is purchased. When VMM is covered, it does not cover:

- **glass** parts of a building other than glass building blocks,

- losses by **theft** (but building damage caused by a burglar is covered),

- damage by vandals after the building has been vacant for 30 consecutive days or more.

The **broad form** expands coverage for explosions, vehicle damage and vandalism or malicious mischief. It also adds coverage for the following perils not covered by the basic form:

- damage to **covered property** caused by burglars, but not theft of property (the basic form only covers building damage by burglars);

- damage caused by **falling objects** (damage to a building's interior or its contents is covered only if the falling object first damages the roof or an exterior wall);

- damage to a building or its contents caused by weight of **ice, snow, or sleet**;

- **accidental discharge or overflow of water or steam** from a plumbing, heating, air conditioning system or fire protective sprinkler system, or from a household appliance (but not damage caused by freezing or continuous seepage);

- sudden and accidental **tearing apart, cracking, burning, or bulging** of a steam or hot water heating system, an air conditioning or automatic fire protective sprinkler system, or an appliance for heating water;

- **freezing** of a plumbing, heating, air conditioning or automatic fire protective sprinkler system, or of a household appliance;

- sudden and accidental damage from **artificially generated electrical current** (but not damage to a tube, transistor, or similar electrical component).

The burglar and discharge or overflow perils are suspended whenever the dwelling has been vacant for more than 30 consecutive days.

The freezing peril is suspended whenever the dwelling is vacant, unoccupied, or being constructed, unless reasonable care was taken to maintain heat in the building, or to shut off the water supply and drain systems and appliances.

The **special form** provides the most complete coverage. Coverages for the dwelling and other structures are provided against **any risks** which are not excluded. **Personal property** is insured against all the broad form perils.

If any excluded loss is followed by a loss which is not excluded, **the additional loss is covered** by the special form.

> Example: If you experience a loss that involves water damage from a fire protective sprinkler system, the policy will cover the loss caused by water and the cost of tearing out and replacing any part of a building necessary to repair the sprinkler system. But it will not cover any damage to the system itself.

Minimum amounts of insurance are usually required for the broad and special forms. This is because people sometimes choose very **small amounts of coverage** for dwelling insurance. (Since the policies only cover the value of buildings—which usually aren't primary residences—minimizing dwelling coverage can make sense.)

PROPERTY AND LOSSES COVERED

There are **insuring agreements** and **exclusions** for the types of property and losses that are not covered under a dwelling policy.

A total of five insuring agreements are found on dwelling forms. Three describe property covered, and two describe specific types of covered losses. The available coverages are:

- Coverage A—Dwelling
- Coverage B—Other Structures
- Coverage C—Personal Property

- Coverage D—Loss of Fair Rental Value
- Coverage E—Additional living expense (not included on the basic form)

Dwelling coverage applies to the dwelling described in the declarations—and to all **attached structures** and **service-related building equipment** at the described location. This coverage also insures **materials and supplies** on or adjacent to the described location for use in the construction, alteration, or repair of the dwelling or other structures.

Other structures on the described location which are separated from the dwelling by a clear space, or connected only by a fence, utility line, or similar connection, may be insured under Coverage B.

Coverage C applies to personal property which is **at the described location, usual to dwelling occupancy** and **owned or used** by you or members of your family. If personal property is moved to a newly acquired principal residence, this coverage will automatically apply at the new location for **30 days**—but not beyond the policy expiration date.

Coverages D and E provide insurance for **indirect losses.**

Coverage D pays the **fair rental value** of that part of the described location rented to others or held for rental at the time of damage.

> Fair rental value means the rental value minus expenses which do not continue (such as heat and electricity) while the property is unfit for use.

Coverage E pays **additional living expenses** incurred by the insured while the property is unfit for use.

> Additional living expense means any necessary increase in living expenses (such as rent for alternative housing) incurred so that the household can maintain its normal standard of living.

If a **civil authority** prohibits use of the insured property because a peril insured against has damaged a neighboring location, dwelling forms limit payments under Coverages D and E to a maximum period of **two weeks**.

All three of the dwelling forms include **other coverages**, which are extensions of the major coverages. The basic form includes **eight** other coverages. The broad and special forms make some modifications to **these coverages and include three additional** coverages. The extensions of coverage are:

- the cost of removing personal property from a location;

- damage to other structures at the location;

- debris removal expense;

- tenant's improvements, alterations, and additions;

- worldwide personal property coverage;

- rental value or combined rental value and additional living expense;

- reasonable cost for repairs;

- fire department service charges;

- lawns, trees, shrubs, and plants (broad and special forms only);

- collapse of a building (broad and special forms only);

- breakage of glass or safety glazing material (broad and special forms only).

All three dwelling forms **exclude coverage** for the following items:

- **accounts**, bank notes, bills, bullion, coins, currency, deeds, evidences of debt, gold other than goldware, letters of credit, manuscripts, medals, money, notes other than banknotes, passports, personal records, platinum, securities, silver other than silverware, tickets and stamps;

- **aircraft** and parts, other than model or hobby aircraft;

- **animals**, birds, or fish;

- **boats** other than rowboats or canoes;

- **credit cards** and fund transfer cards;

- **data**, including data stored in books of account, drawings or other paper records, electronic data processing tapes, wires, records or other software media;

- **intentional loss** arising out of any act committed by or at the direction of the insured, or any person or organization named as an additional insured, with intent to cause loss;

- **land**, including the land on which the dwelling or other structures are located;

- losses caused by **neglect of the insured** person to use all means to save and preserve property;

- losses caused by **ordinance or law**;

- losses caused by perils having **catastrophic potential** (the policies contain common exclusions for losses caused by flood and surface waters, earth movement, nuclear hazards and acts of war);

- losses caused by **power failure**;

- **motor vehicles**, other than motorized equipment which is not subject to motor vehicle registration and which is used to service the described location, or is designed to assist the handicapped;

- **motor vehicle equipment** and accessories, and any device for the transmitting, recording, receiving or reproduction of sound or pictures which is operated by

power from the electrical system of a motorized vehicle, including tapes, wires, discs, or other media for use with such device, while in or upon the vehicle;

- structures **rented or held for rental** (except as a private garage) to any person who is not a tenant of the dwelling;

- structures used in whole or in part for **commercial, manufacturing, or farming** purposes;

- under coverages for fair rental value and additional living expense, any loss or expense due to **cancellation of a lease or agreement.**

MISCELLANEOUS DWELLING ENDORSEMENTS

Although **dwellings under construction** are eligible for dwelling policy coverage, an endorsement must be attached to modify some of the policy provisions, particularly provisions concerning the amount of insurance and the premium.

The amount of insurance shown for a dwelling under construction is a provisional amount, usually based on the expected completed value. The amount of coverage actually in effect on any given date is a percentage of the provisional amount, based on the proportion that the actual value at the time bears to the completed value.

Normally, a dwelling policy would cover the **actual cash value or replacement cost** of damaged property. It would not cover any additional expenses resulting from the enforcement of building codes that require the use of **improved materials or safety systems** that were not required when the original structure was built.

> For an additional premium, an endorsement may be attached to a dwelling policy to cover the additional loss that may result from any ordinance or law regarding the construction, repair or demolition of property.

Under the **earth movement exclusion,** there is no coverage for earthquake or other forms of earth movement, including earth sinking.

> For an additional premium, coverage for sinkhole collapse may be attached to the policy.

Loss by **sinkhole collapse** means actual physical damage caused by sudden settlement or collapse of the earth supporting the insured property resulting from underground voids created by the **action of water** on limestone or similar rock formations.

An endorsement may be attached to cover various building items owned by **condominium unit owners.**

A limit of insurance must be shown for this coverage and an additional premium will be charged.

> Covered unit-owner building items may include property which you are responsible for insuring under any agreements with other property owners.

For an additional premium, an endorsement may be attached to provide coverage for losses caused by **water which backs up through sewers or drains** or which overflows from a sump pump, even when caused by mechanical breakdown of the pump. Normally these losses would be excluded.

> A variety of other endorsements may be used to provide special coverages and to modify policy provisions in ways that meet the needs of particular insureds.

CONCLUSION

This chapter discussed and provided you with the modifications of policy language and structure that are necessary for insuring a **residence not covered under traditional homeowners insurance.**

The next chapter will discuss the modifications necessary for policies that are made to cover non-owners of dwellings, or renters.

CHAPTER 7

COVERAGES AND ISSUES FOR RENTERS

You don't have to own a five-bedroom Georgian home in the leafy suburbs or a half-million dollar co-op in a hip urban enclave to need insurance on the place where you live and the things that you own. Even if you're just renting your first apartment out of school, you may have things you need to protect—computers, TVs and VCRs, stereo equipment, sports equipment and so on. These things can be worth thousands—or tens of thousands—of dollars.

So, it's surprising that less than half of all renters in the United States bother to protect their personal belongings and furnishings with insurance. People under 40 are particularly remiss.

Tenant advocacy groups and others—like Illinois-based Condominium Insurance Specialists of America—estimate that as few as one in four renters in their twenties and thirties buy insurance. The number remains low—even though renters insurance is relatively cheap and easy to get.

The HO-4 insurance policy form—called the **renters policy** in the insurance industry—is available from most property and casualty insurance companies. Some confusion comes from the fact that the coverage is called different things by different companies— the **contents broad form**, **broad theft coverage** or **tenants insurance**—but, whatever it's called, the coverage is inexpensive enough for just about any renter.

THE MECHANICS OF RENTERS INSURANCE

All personal property is insured against loss by the **broad form perils** under an HO-4 policy.

The policy is purchased most often by renters of apartments, dwellings or condominiums who do not require the complete range of coverages—liability coverage, dwelling structure coverage, etc.—provided by the other standard homeowners forms.

A renter doesn't usually need to insure the building in which he or she lives. And renters who don't want to pay for liability protection can opt for a policy that covers only personal property.

THE IMPORTANCE OF COVERAGE

Landlords will sometimes require that their tenants carry some form of renters insurance. (This usually

applies to luxury apartments or, conversely, rent-controlled units.) In states with large urban centers, insurance and housing regulators have outlawed these requirements in the name of consumer protection.

Unfortunately, these prohibitions send the message to many people that renters insurance is a rip-off. That's unfortunate because renters policies can be a bargain.

> Example: In the mid-1990s, USAA—the Texas-based insurance company that specializes in covering military and former service personnel and their families—offered a tenant protection plan that cost $169 a year in New York City and insured $20,000 worth of belongings, with a $100 deductible. The policy also provided replacement cost coverage—and $100,000 of personal liability coverage.

Renters insurance can either be written in a comprehensive form for **all risks** that aren't explicitly excluded or for **named perils** only. Named perils coverage averages about 20 percent less expensive, because the losses it covers are more limited.

> Even insurance written on a named perils basis should cover fire, theft or water damage. These are primary hazards that renters face.

Although it doesn't cover the building itself, an HO-4 policy does provide a limited amount of coverage for **building additions and alterations**. (This coverage is also known as **leasehold improvement insurance**.) In short, this means that if you spend money to improve the apartment or house you're renting—and haven't been reimbursed by your landlord—the renters insurance will cover the investments you've made in the place.

How much coverage you need depends, of course, on the value of your belongings. You may want to refer to Chapter 2 of this book for the assets inventory. Once you've calculated the value of the things you own, you simply have to ask yourself how much of this you could stand to lose.

> If you don't own more than a few hundred dollars of any specific kind of personal property, you probably don't need renters insurance. But, if you care enough about a hobby, activity or other experience to invest thousands of dollars in related equipment, you probably do want to insure those things.

INSURING AGAINST THEFT

One reason that renters insurance is so attractive is that it covers personal property against theft.

By comparison, basic dwelling policies do not provide any theft coverage for personal property. A broad theft coverage endorsement has to be added to a dwelling policy—at additional premium—to provide such coverage.

For many insurance companies, the **broad theft coverage endorsement**—sold in a slightly different version as stand-alone insurance—is renters insurance.

Theft coverage provides insurance against loss by the following two perils:

- theft, including attempted theft, and
- vandalism and malicious mischief as a result of theft or attempted theft.

A caveat: The vandalism coverage won't apply if your residence has been vacant for more than 30 consecutive days immediately before the loss. In most cases, though, this limit won't be an issue for renters.

Broad theft policies (or endorsements) contain three definitions that affect the coverage:

- **business** means any trade, profession or occupation;
- **insured** person means the named insured and residents of the named insured's

household who are either relatives of the named insured or under the age of 21 and in the care of any insured person;

- **residence employee** means an employee of any insured who performs duties related to maintenance or use of the described location, including household or domestic services, or similar duties elsewhere which are not related to the business of any insured person.

Property used for business purposes **isn't considered personal property** and, therefore, isn't covered.

Only property that belongs to **an insured person** is covered—so, if the $2,000 camera you're keeping for a friend gets stolen from your trendy downtown loft, you may have some explaining to do.

Finally, property of **residence employees** is covered only if you ask the insurance company to add language saying so. This may raise your premium—though many companies will add the coverage for no additional cost.

A limit of liability must be shown for on-premises coverage. This limit is the most the insurer will pay for any one covered loss at the described location. On-premises coverage applies while the property is:

- at the part of the described location occupied by an insured person;

- in other parts of the described location not occupied exclusively by an insured person, if the property is owned or used

by an insured person or a covered resi-
dence employee;

- placed for safekeeping in any bank, trust
 or safe deposit company, public ware-
 house, or occupied dwelling not owned,
 rented to or occupied by an insured per-
 son.

This type of insurance limits coverage either with one
general dollar limit or a range of dollar limits appli-
cable to different types of personal property. In the first
case, a policy would insure all your property—regard-
less of type—to a limit of $20,000. In the second, a
policy would insure computer equipment up to $5,000,
stereo equipment to $2,000, sports equipment to
$1,500, etc.

Although limits of liability are shown for the maxi-
mum amount of insurance for any one loss, special
sub-limits of liability usually apply to specific cat-
egories of insured property. Each limit is the most the
insurer will pay for each loss for all property in that
category.

An example of the special limits of liability might be:

- $200 for money, bank notes, bullion, gold
 and silver other than goldware and sil-
 verware, platinum, coins and medals;

- $1,000 for securities, accounts, deeds, evi-
 dences of debt, letters of credit, notes
 other than bank notes, manuscripts, pass-
 ports, tickets and stamps;

- $1,000 for watercraft including their trail-

ers, furnishings, equipment and out-
board motors;

- $1,000 for trailers not used with water-
craft;

- $1,000 for jewelry, watches, furs, precious
and semiprecious stones;

- $2,000 for firearms;

- $2,500 for silverware, silver plated ware,
goldware, gold plated ware, and
pewterware, including flatware, hollow-
ware, tea sets, trays, and trophies.

Limits similar to these are found on homeowners poli-
cies. The intent of the policies is to provide **basic cov-
erage** for special items of value which may be subject
to theft losses. However, some people collect particu-
lar items and may have **disproportionate exposures**
not contemplated in average insurance rates. Most
policies will not allow the full limit of liability to be
applied to a specific kind of property.

> **If you have greater exposures, higher limits
> may be available for an additional premium
> charge, or a separate personal property
> floater may be purchased.**

In some cases, **off-premises theft coverage** is avail-
able. Off-premises coverage applies while the prop-
erty is away from the described location if the prop-
erty is either:

- owned or used by an insured person, or

- owned by a residence employee while in a dwelling occupied by an insured, or while engaged in the employ of an insured.

Example: If you ride your $2,000 mountain bike from the houseboat you're renting to the mountains north of Seattle—and someone steals it while you're waiting to pay for a cafe latte—the insurance company will get you a new bike.

A number of **conditions** apply to off-premises coverage:

- you can only buy it if you've bought **on-premises coverage**,

- a **separate limit of liability** must be shown for off-premises coverage (this limit—usually lower than on-premises limits—is the most the insurer will pay for any one loss),

- off-premises coverage does not apply to property that you move to a **newly acquired principal residence**.

That last point is a considerable issue in renters insurance.

One of the ways in which insurance companies shield themselves from the volatility that sometimes accom-

panies the renter's lifestyle is by limiting the **transferability** of a renters policy from one location to another.

If you move during the policy term to a new **principal residence**, the limit of liability for **on-premises coverage** will apply at **each residence and in transit between them** for a period of 30 days after you begin to move the property. When the moving is completed, on-premises coverage applies at the new described location only.

PROPERTY NOT COVERED

Broad theft coverage **does not apply** to the following types of property:

- **aircraft** and parts, other than model or hobby aircraft;

- **animals,** birds, or fish;

- **business property** of an insured person or residence employee on or away from the described location;

- **credit cards** and fund transfer cards;

- **motor vehicles,** other than motorized equipment which is not subject to motor vehicle registration and which is used to service the described location, or is designed to assist the handicapped;

- **motor vehicle equipment** and accessories, and any device for the transmitting, recording, receiving or reproduction of sound or pictures which is operated by power from the electrical system of a

motorized vehicle, including tapes, wires, discs, or other media for use with such device, while in or upon the vehicle;

- property held as a **sample** or for sale or delivery after sale;

- property of **tenants, roomers and boarders** not related to an insured person;

- property separately described and specifically insured by any **other insurance**;

- property while at **any other location** owned, rented to or occupied by any insured person, except while an insured person is temporarily residing there;

- property while in the custody of any **laundry, cleaner, tailor, presser or dyer** except for loss by burglary or robbery;

- property while **in the mail**.

You may recognize some of these exclusions from standard homeowners and dwelling policies. A number of these recur through all the various forms of household insurance.

The broad theft form adds two conditions that can influence whether or not property (which would otherwise be covered) is covered:

- in addition to standard **duties after loss**, theft coverage requires the insured person to notify the police when a theft loss occurs;

- the **other insurance** condition that ap-

plies to standard homeowners and dwelling forms is changed slightly—if a theft loss is covered by other insurance, the insurance company is only obligated to pay the proportion of the loss that the limit of liability under the theft endorsement bears to the total amount of insurance covering the loss.

WHEN YOU'RE THE LANDLORD

Of course, renters aren't the only people who may need insurance in a rental situation. If you're renting out an apartment or house you own, you have significant exposures to financial loss. However, you may find yourself in an awkward place—lost between the limits of a standard homeowners policy and the technical complexity of commercial landlord coverage.

Fortunately, you can protect yourself against some rental losses. With some modifications, a combination of dwelling insurance and broad theft coverage should meet your needs.

Protection against **tenant theft** deserves particular attention. Even in a case where you feel that you know the renters well, there's the possibility that some of your possessions might disappear during their stay. If so, the chances are good that **you won't collect** on a basic dwelling policy—which insures the house and contents against theft and damage from fire, wind, smoke, vandalism, and other hazards.

> If it turns out that your tenants are the thieves—which does happen sometimes—you'll need more coverage than a standard dwelling policy. You'll need the same theft coverage that the renters themselves should be buying.

There can also be problems if a renter's lack of concern about your property leads him to **forget to double-latch the door or secure a window**—making things easy for a burglar.

If your insurance company learns about this, it might resist paying for some stolen items—on the grounds that the low premium rates for its standard coverage are based on the assumption that **you will be around to help keep the home and contents safe**. At best in this situation, the company might pay for such things as a stolen television set and furniture—but not for missing jewelry, furs, silver, coins, and watches.

So, you need to look again at your homeowners or dwelling policy before you accept a renter's deposit check. In particular, you need to look in the exclusions or conditions section for a clause that reads something like:

> peril of theft does not include any part of loss when the property is rented by the insured to another party.

If your policy has language like this, you may want to convert to an **all-risk** homeowners policy or buy an endorsement broadening your theft coverage.

As we've noted before, you can expect to pay as much as 20 percent more than the cost of a basic policy for all-risk coverage that provides more protection. The endorsement to theft coverage will usually cost less than this—but still 10 to 20 percent more than a standard theft package.

If you rent your home frequently, you may need an even costlier **special multi-peril policy**. This kind of insurance—which is actually a commercial policy—is designed for professional landlords. It covers just about every exposure a landlord faces—and can be modified to insure against various particular risks. But, if you're just renting one house or apartment, you'll probably do best to use **endorsements** to make a standard homeowners or dwelling policy work.

Some part-time landlords may be tempted to avoid the extra insurance and, if there's an insurable loss, simply fail to mention to the insurance company that the incident occurred while the property was rented. This may work. The fact that insurance companies don't like to talk about it suggests it does happen. But this kind of claim can progress quickly from white lie to outright fraud.

For most people who have enough assets to insure, it's better to tell the whole truth and pay a slightly higher premium.

The 1994 New York state court decision *Stuart D. Wechsler v. United Services Automobile Association* considered the details of someone who'd rented out his house and then tried to make a claim under a standard homeowners policy.

Wechsler sued USAA when it denied a claim under his homeowners policy for property stolen while the entire premises was rented. In February 1993, a state trial court granted summary judgment in favor of USAA. Wechsler appealed.

The appellate court held that the policy unambiguously excluded from coverage for property stolen while the entire premises was rented. It concluded:

> The [trial] court properly determined that the plain language of the homeowners policy exclusion for theft loss for "that part of the residence premises rented by an insured to other than an insured" was unambiguous in excluding from coverage property stolen when the entire premises was rented.

EXCHANGING HOMES

The practice of **exchanging homes**—you stay in another family's place while they stay in yours during vacations—can present a different kind of problem when the exchange includes use of the family car. What if someone using your home has an accident with your vehicle? Or if you have a collision as you drive an unfamiliar car in a foreign country?

In the U. S. and Canada, your car insurance—collision and liability—automatically remains in effect as long as the driver has your permission to get behind the wheel. It's not always like that elsewhere.

You may want to consider increasing your personal liability insurance to safeguard your assets—just in case, for example, a renter who's unfamiliar with that low cellar doorway suffers a concussion and decides to sue.

If you're thinking about turning your house over to guests of any sort for more than a few days, you probably want to expand your homeowners or dwelling policy. Typically, an all-risk homeowners policy provides for $2 million worth of liability insurance—you may need this if the house you're swapping has a swimming pool, sauna bath or other potentially dangerous amenity.

The broader protection can also be useful in some unusual situations. One insurance broker told a national business magazine about a client whose alcoholic renters destroyed an expensive sofa by spilling drinks and dropping cigarettes on it during their stay.

Damage caused by renters or people who use your house in an exchange will usually be considered normal wear and tear—and not be covered by a basic policy. In these cases, an all-risk or special form policy may be worth the extra premium cost.

Finally, you may want to **manage some risks** when you loan your house or join an exchange program. If possible, try to control the kind of people who will use your place. People who have travelled or exchanged homes before will usually be better guests than people who are new to the process. Families with older children will be less inclined toward dangerous situations than families with toddlers.

CONCLUSION

Overlooking insurance when it is necessary can be a big mistake. Even if you are not a homeowner you probably have belongings of value (at least to you). Fortunately, there are policies available for renters to insure protection in the case of theft and more.

> Renters insurance is one kind of coverage that most people agree is a bargain for consumers.

No matter what type of living arrangement you have, the price of a household's insurance is an important issue. Chapter 8 will discuss how insurance companies go about pricing their homeowners coverages, as well as show you how to compare the prices and level of service among competing companies to select the package that's right for you and your home.

HOW INSURANCE COMPANIES PRICE HOMEOWNERS COVERAGE

When you're shopping for homeowners insurance, it's important to understand the **methods and concepts** of how insurance companies set—the industry term is **rate**—their policies.

> In order to get the right price, you need to understand how insurance companies look at you and how they look at your home...and apply those to the rules of the homeowners policy forms.

In the 1990s, significant coverage losses have caused insurance companies to reassess the relationship of homeowners insurance to their bottom lines. Traditionally a lucrative product, homeowners coverage has not produced a profit, on average for the industry, since the late 1980s.

In the years between 1988 and 1994, North America experienced **seven of the 10 costliest property-damage disasters** in its history. Tax write-offs and investment income offset much of the impact of those claims, but insurance companies have spent most of the 1990s looking for other ways to limit their losses.

MARKET TRENDS

The insurance industry is continually changing to **simplify procedures, clarify policy language, improve efficiency and increase competition**. Some of these changes come from the industry itself—others are influenced by laws, regulators and consumers.

The industry standard for **pricing rules and policy forms** has traditionally been the Insurance Services Office (ISO) or Mutual Services Office (MSO) rating bureaus. However, in the wake of the late 1980s wave of disasters, many insurance companies have developed **their own manuals, rates and policy forms** for coverages such as the standard homeowners and dwelling programs.

One recent development in policy rating plans is the concept of **loss cost rating**. Since most companies had started developing their own **personal lines** insurance manuals, rates and forms in the 1980s, many people haven't noticed any difference. But there is an important one.

The industry-standard manuals changed as loss cost rating was implemented across the country. Traditionally, ISO advisory rates reflected **industry averages** of member insurance companies. These were based on

statistical information supplied by the member insurance companies. The data supplied and used to develop **advisory base rates** include **four basic components**:

- actual **claims payments** to policy owners,

- **loss adjustment** expenses (including claims department overhead, legal expenses, etc.),

- **underwriting** expenses (including commissions, acquisition costs, overhead, taxes, fees, etc.),

- **underwriting profit** (including investment income, capital costs, surplus requirements, underwriting portfolio and market conditions).

The claims payments and loss adjustment expense components are called the **prospective loss costs**. These can be difficult for individual insurance companies to calculate with sufficient credibility if they use only their own loss information.

> By calculating this data for the entire industry, a group like ISO can supply more reliable estimates because of the large amounts of data than can be obtained from the hundreds of member companies.

Under the traditional rating system, insurance companies would use the advisory base rates as the starting point for setting premiums for homeowners insurance. To these base rates, the companies would add factors taking into account specific data like the location of the home, its size and assessed value.

PROSPECTIVE LOSS COSTING

Credible **loss projections** are necessary for the company to charge the proper premiums.

Since the traditional advisory rates were industry averages, a standard rate might be much higher or much lower than a particular company's actual expenses. An individual company's **claims management philosophies and financial strategies** were not fully considered when using average rates provided by ISO.

In 1989, ISO began a transition from providing advisory base rates to a program which would provide only the **prospective loss costs.**

> Under this program, each individual insurer would develop rating factors to reflect its own underwriting expense and underwriting profit components. It can then adapt industry-wide rating numbers as a starting point for calculating premiums.

If the insurance company does not develop its own numbers, it has to provide its staff and salespeople with

instructions for use of a specific location's **individual rating factors** and the ISO industry-average prospective loss costs. This can make comparing policies difficult.

> Having a basic understanding of the application of rules under the traditional rating procedures will make it easier for you to follow market changes. A knowledge of theory is often as important as the knowledge of practical application.

NEW RATINGS LEAD TO SOME RATE HIKES

In the early 1990s, State Farm Mutual Insurance Co. scrapped with the California Insurance Department over a changing rating system that effectively raised premiums without regulatory approval.

The state regulators complained that State Farm increased—on a regular yearly basis—the **estimated assessment values** of homes it insured. This raised **premiums** as well as the **deductible amount** on certain special **endorsements** (like earthquake coverage).

At the same time, State Farm was petitioning the state to allow it to eliminate the **guaranteed replacement-cost** coverage in its homeowners policies.

> With guaranteed replacement-cost coverage,
> someone whose home is destroyed can have
> it replaced at full value, regardless of limits
> stated in the policy. If a house is insured for
> $250,000 but costs $350,000 to replace, the
> insurance company pays $350,000.

State Farm asked for a coverage limit of **120 percent of any stated policy limit**. This would have forced policy owners to buy higher coverage limits in order to guarantee replacement cost.

The standard California policy rating rule stated:

> To determine the amount of insurance required to equal 80 percent of the full replacement cost of the building immediately before the loss, do not include the value of:
>
> (a) Excavations, foundations, piers or any supports which are below the undersurface of the lowest basement floor;
>
> (b) Those supports in (a) above which are below the surface of the ground inside the foundation walls, if there is no basement; and
>
> (c) Underground flues, pipes, wiring and drains.

In calculating or determining the **full replacement cost** of the building immediately prior to the loss, the company was allowed to exclude from the cost the value of the listed items in the above clause—such as

the cost of excavations, foundations, piers, etc. These can add up to an appreciable amount.

The exclusions would reduce the replacement cost, thereby lowering the amount the insurance company would have to pay under a guaranteed-replacement-cost policy.

This procedure was what the California insurance regulators took exception with.

In the standard guaranteed-replacement-cost policy form, the insurance company states:

> We will pay no more than the actual cash value of the damage until actual repair or replacement is complete. Once actual repair or replacement is complete, we will settle the loss according to the provisions [described] above.
>
> However, if the cost to repair or replace the damage is both:
>
> (a) Less than 5 percent of the amount of insurance in this policy on the building; and
>
> (b) Less than $2500;
>
> we will settle the loss according to the provisions [described] above whether or not actual repair or replacement is complete.

The standard policy form contains this condition so that the insurance company can be certain that the insured building is actually repaired when a loss has occurred.

In the event of loss to a covered building, the policy will first pay the loss on an actual cash value basis. At the time the repairs are complete, the policy will pay the balance of the claim to bring the amount up to full replacement cost.

The **policy provisions** mentioned in these passages refer to the standard policy's 80 percent coinsurance clause; it must be met for the condition to operate.

> **If the amount of the loss is less than 5 percent of the amount of the building coverage and under $2,500, the policy will pay strictly on the basis of replacement cost.**

State Farm's process would have allowed a policy owner with a $250,000 policy on a house worth $350,000 to get only $300,000. To ensure full replacement value, that policy owner would have to ask for an increase in the policy limit to about $290,000. That, in turn, would mean **higher premiums**.

RATES AND PREMIUMS

As we've noted, rates for homeowners policies are based on a number of factors which may or may not increase the chances of certain occurrences. The following are a few of the **factors** that insurance companies use to adjust their prospective loss cost bases:

- **Location**. Companies keep records of the claims they've had to pay, dividing terri-

tory by cities, zip codes, and even neighborhoods, to determine the risk of insuring homes. Residents of areas with traditionally high losses—from crime, fires, or natural disasters—can expect to pay more than residents of low-loss areas.

- **Fire-protection class.** How close is your home to the nearest fire station? How well-trained are the firefighters? The closer you are and the better they're trained, the lower your premiums should be. ISO assigns every neighborhood in the U.S. a fire-protection class, based on the quality of fire protection and the distance of homes from a water source. (Some large insurance companies use their own rating systems.) So, a rural home miles from a fire station may cost more to insure than an urban home in a higher-crime area but around the corner from a firehouse.

- **Type of building.** Wooden houses generally cost 5 to 10 percent more to insure than brick ones, which better withstand fire. (Earthquake insurance, however, costs considerably less for wooden homes.)

- **Age of home.** Companies may charge up to 20 percent less to insure new homes than to insure older ones, which may be more susceptible to damage in storms and fires. Outdated building standards and old wiring can also make older homes riskier to insure.

- **Construction costs.** The cost for building materials and labor vary greatly from one part of the country to another. The more it would cost the insurer to repair or rebuild your home, the higher your premium is likely to be.

- **Number of units.** Companies may charge more to insure apartments or condominiums in large buildings than in small ones because the risk of fire increases with the number of occupants.

Other factors can also contribute to the final premium quote an insurance company gives you.

Usually all the insurance on a home is written in one policy. However, occasionally, a company may not wish to write the entire amount—due perhaps to a high value dwelling and contents with a severe exposure to fire loss. In such cases, more than one company will share the risk (one company covering the dwelling part, one the liability part). If there is a loss, special clauses provide for the **proportionate sharing** of the loss payment according to the amount written by each company.

Homeowners policies are sold with **deductibles**, the part of the loss you must pay on each claim before your insurance company kicks in. If you have a policy with a $250 deductible and you suffer a $700 loss, you pay $250 and your insurer pays $450.

The higher your deductible, the lower your premium. If you raise the deductible from $250 to $500, you may be able to trim more than 10 percent off your premium. Raise it to $1,000 and you could save more than 25 percent.

EARTHQUAKE COVERAGE—A STEEP PRICE

Earthquakes can wreak serious financial damage, whether you own or rent. Insuring against earthquake damage can be difficult, because—even though there are standard policy forms—insurance companies have significant latitude in how they price the coverage.

After an earthquake, most insurance companies put a 10- to 60-day moratorium on issuance of new quake coverage. Other things you should know about earthquake insurance:

- **Premiums are based on property value, type of construction and location.** The cost for wood-frame construction ranges from $1.50 to $3.00 per $1,000 of coverage, depending on location. Lower rates apply in the central part of the state; higher rates in the coastal counties and those along fault areas. Coverage is typically written with a deductible of 10 percent of the insured value of the dwelling and contents.

- Earthquake-caused **fires are typically covered** under homeowners policies.

- **Coverage of aftershocks varies by company.** Aftershocks tied to an earthquake are covered under the initial claim so that the deductible would not apply again. But when two to four days separate the aftershock from the initial tremor, it becomes more questionable whether it is an aftershock or a new quake. Ask before you buy.

- **Renters can add earthquake insurance** to an existing fire or renters' package to cover damage to household contents and personal belongings.

In a 1994 hearing in San Francisco, California, insurance regulators again sparred with State Farm, this time accusing the big insurance company of using *questionable tactics* to boost its earthquake insurance premiums.

A state administrative law judge considered the regulators' broad challenge to State Farm's rate structure and business practices in a hearing prompted by State Farm's application for an 8.3 percent increase in its premium rates for homeowners insurance—and a 23.2 percent increase in premiums for personal-liability umbrella insurance.

The California DOI argued that: "State Farm [is] using questionable tactics to effectively increase premiums without obtaining official permission."

To support its argument, the DOI cited the company's practice of annually increasing the estimated values of homes it insures. This raises not only premiums,

but also the deductible amount on earthquake insurance.

State Farm had stopped trying to grow in California—at least in homeowners insurance. Stung by such disasters as the Loma Prieta and Northridge earthquakes—and the Oakland Hills and Southern California fires—the company started turning down new applicants in the state.

"A prospective policyholder now must wait until an old one drops out before being allowed to sign up with State Farm. The company calls this *exposure management*," the California DOI complained.

However, the reality of the marketplace worked against the regulators arguments and in favor of State Farm's.

CONCLUSION

Changes in how insurance industry trade groups calculate basic rating information has had the unintended—though not unforeseen—effect of **allowing insurance companies greater freedom to use discretion** in pricing policies. As one industry report concluded:

> As part of the recent modernization of the dwelling program, general rules and rating rules which were common in most states have been consolidated into expanded country-wide rules. As a result, the new ISO manual for the dwelling policy program now includes fewer state exception pages. Additionally, rating has been simplified and fewer steps are

involved in calculating premiums for dwelling policies.

> The result: Comparing coverages offered by different companies is more difficult than before—but more important than ever.

Insurance companies use the rating process to determine how much to charge different homeowners for the amount and type of coverage they need. Because the base rates that serve as a starting point have become more generic, most of the pricing process now focuses on a specific insurance company's experience.

While information such as location, building materials, age of building, etc., are essential to an insurance company when generating a premium quote, other subjective factors—such as the company's claims-paying procedures and investment income—play a growing role in the quote.

> These changes make the financial strength of the insurance company—which has always been important—more important than ever.

This chapter has given you the basic information needed to understand these rating procedures—and to determine what type of coverage will be best for you.

ASSIGNED-RISK PROGRAMS AND ALTERNATIVE MARKETS

In the wake of the riots in the Los Angeles area after the first Rodney King police brutality trial, many people who live in big cities around the country started checking their homeowners insurance policies for **riot coverage**. Most didn't like what they found.

Until the mid-1960s, riot coverage for homeowners property losses had been widely available as part of standard packages. The outbreak of civil disorders in urban centers during the mid- and late-1960s changed all that. Insurance companies began to **exclude riot damage from standard policies**—and some stopped writing homeowners insurance at all in urban centers.

In addition to concern about the riot risk, insurers were increasingly unwilling to insure property in neighborhoods characterized by **congestion and deterioration**. Inner city homeowners and business owners soon found that property coverage was becoming unavailable or unaffordable.

> Unfortunately, the absence of insurance usually accelerates the process of economic decline. Banks and other lenders require insurance coverage to protect their loans. When insurance is not available, lenders will not make loans for mortgages or new construction. Real estate transactions therefore cease, construction comes to a halt, jobs are lost, and the local economy stagnates or deteriorates.

To remedy the growing urban problem, the U.S. Congress created a federal riot reinsurance program. The **Urban Property Protection and Reinsurance Act** made riot reinsurance available through the **National Insurance Development Fund,** which is operated under the Department of Housing and Urban Development (HUD).

> Residents of high-crime areas who have the required security devices also may qualify for insurance with the Federal Crime Insurance Program. The policy covers only losses due to burglary or robbery. Call the Federal Crime Insurance Program at (800)-638-8780 for details.

THE FEDS AND FAIR PLANS

By law, any insurance company that wishes to buy riot reinsurance must participate in a HUD-approved FAIR plan. The term FAIR stands for **Fair Access to**

Insurance Requirements. These plans were created to make essential property insurance available to consumers in areas where coverage had become unavailable, or at least extremely difficult to obtain, due to conditions which are beyond the control of property owners.

> FAIR plans are state supervised insurance pools that provide bare-bones homeowners and dwelling insurance in high-risk areas. The federal riot reinsurance is available only in states that have acceptable FAIR plans. The plans are in operation in approximately 30 states.

FAIR plans are often referred to as **assigned-risk programs.** This term, most often associated with auto insurance, applies to any state-run program that helps high-risk property owners find insurance.

In addition to homeowners coverage for condos and separate coverage for other dwellings, risks which are not ordinarily acceptable by insurance companies are assigned to an insurer that participates in an Assigned-risk program.

> Example: Residences located in flood plains or fire zones—even if they are large homes in good neighborhoods—will often have to use a FAIR plan to get insurance.

Although they are administered by the states, FAIR plans are operated exclusively by **participating insurers**. Insurance regulators will usually require insurance companies that do business in their state to participate in the FAIR plan in proportion to the amount of state-wide premiums they write in the **voluntary market** (that is, everything that's not assigned risk).

> **Example: If Prudential writes 10 percent of the standard homeowners insurance in a given state, it will be required to write 10 percent of the high-risk policies in the state's FAIR plan.**

Consumers who qualify can **buy FAIR plan insurance** just like they would buy insurance from a company—directly or through licensed agents representing the participating companies.

However, each state can regulate its FAIR plan as it chooses, so there are slight variations in how each plan is run.

FAIR plans make coverage available only in **designated areas**, which may include entire cities or counties, or may be defined by ZIP code or other geographical boundaries. In some cases, the designated area includes the entire state.

THE CALIFORNIA FAIR PLAN

Because of California's large geographical area, and the size of designated brush hazard areas, California

FAIR Plan business represents a substantial proportion of all FAIR plan business written in the country.

> Approximately 45 percent of all FAIR plan business written nationwide consists of risks located in California.

The California FAIR Plan Association is an industry-wide association consisting of all insurers who have Certificates of Authority to write fire insurance in the state. Information about **applications, inspections, procedures, available limits or other operational details** can be obtained by contacting the FAIR plan directly.

The California FAIR Plan—like most such plans—is intended to be **an insurer of last resort.** Property owners are usually required to make an effort to obtain coverage in the voluntary market before submitting an application to the FAIR plan.

> Any person having an insurable interest in real or tangible personal property in an officially designated area who has been unable to obtain basic property insurance through normal channels from an admitted insurer or a licensed surplus line broker, is entitled to make an application for coverage to the FAIR plan.

Coverage may not be refused because of **environmental conditions** (such as a deteriorated neighborhood or local brush fire hazard) which are beyond the control of the applicant. However, the property must be **insurable**—it must satisfy the FAIR plan's basic underwriting criteria.

A FAIR plan can change the designated areas in which it will write coverage. Changes in designated areas may only be made by the Insurance Commissioner and the Department of Insurance.

> Example: Following the Northridge earthquake in January 1994, insurers became reluctant to write dwelling and homeowners coverage in California—due to a state law that earthquake coverage must be offered in connection with residential property insurance. Coverage rapidly became unavailable for many consumers. To remedy this problem, the Insurance Department expanded the FAIR Plan areas to include all areas statewide.

SPECIFIC FAIR PLAN TERMS

The California FAIR Plan issues policies to cover **dwelling** risks, **commercial property** risks, and **businessowner** property risks. Different policy forms are used for each of these risks—and different maximum amounts of insurance are available for each. Here are a few of the policies:

- **Dwelling Policies**. The maximum available limit for all coverages under a dwelling policy is $1.5 million per location. This is a combined maximum amount of insurance. Separate policy limits for dwelling coverage, other structures, personal property, and any endorsements that provide additional coverages cannot exceed $1.5 million in total.

- **Commercial Property Policies**. Under general underwriting guidelines, the maximum available limit for commercial buildings is $3 million per building. Separate limits apply to commercial contents, and various limits ($1.5 million to $10 million) are available.

- **Businessowners Policies**. The maximum available limit for property coverages under a businessowners policy is $2 million for the building and $1 million for business personal property. These are separate limits. Businessowners policies also include liability coverages, and offer optional burglary and robbery coverages.

Dwelling and commercial property policies issued by the FAIR plan are written with a **standard deductible** of $250 per occurrence. Higher optional deductibles (such as $500, $1,000 or $2,500) are available. The deductible applies to most of the property coverages. However, if earthquake coverage is written, a separate 10 percent deductible applies to earthquake losses.

TIPS FOR FAIR PLAN APPLICANTS

As is usually the case, a licensed agent can help you determine the appropriate amounts of insurance and assist you in obtaining supplementary coverages which may not be available through the FAIR plan (such as theft and liability coverages).

> All applications submitted to the Plan must be on a brokerage basis—which means the agent or broker is a legal representative of the applicant and not the FAIR plan.

Other points that consumers should keep in mind when applying for FAIR plan coverage:

- All information on the application must be complete and correct. Incomplete applications will usually be returned unprocessed.

- An application must be signed by the applicant or an agent on the applicant's behalf.

- No deposit is required, and no premium should be submitted with the application.

- FAIR plans are not usually as service-oriented as traditional insurance companies. They won't issue quotations over the phone. In most states, quotes are pro-

vided only through the mail after a completed application for coverage has been submitted and reviewed.

- Initial quotations may be provisional, subject to termination if the risk is found to be uninsurable on the basis of an inspection, or subject to adjustment if an additional premium is required on the basis of an inspection and rating report.

- Since agents and brokers are representatives of the applicant, they do not represent the FAIR plan. Temporary coverage may be provided only if the FAIR plan issues a provisional quotation and the premium is paid.

> A commitment to coverage can only be made by the FAIR plan if it finds that a submitted risk satisfies its general underwriting requirements.

Occasionally, an agent or broker will claim that he or she can get you FAIR plan coverage **automatically or immediately**. This isn't usually true. While an agent might be able to get insurance with a traditional insurance company that's effective immediately (the technical term for doing this is **binding** you to coverage), that's not possible with assigned-risk insurance.

An important note: The only payment you have to make to an agent or broker is the standard commission set by the state for FAIR plan business. Agents usually may not charge additional fees for handling FAIR plan coverages. They are not permitted to charge any fees for inspecting property, providing service, or assisting in the completion of FAIR plan applications and forms.

Any required consumer rights **disclosure statements** should be provided concurrent with the application for insurance. Applications should be accompanied by a signed acknowledgement of receipt of disclosure forms.

Disclosure statements usually describe the various coverage options and conditions available to insurance buyers. In California, the following three options are available under policies issued by the FAIR plan:

- **Replacement Cost Coverage.** This coverage option provides dwelling coverage on a replacement cost basis. If there is a covered loss to the insured dwelling, the insurance company will pay to **repair or replace** the property with like construction, but only up to the policy's limit of liability. The recovery will be reduced by any deductible the insured has agreed to pay. To be eligible for replacement cost coverage, the dwelling must be insured for at least **80 percent of its replacement**

cost at the time of loss. Replacement cost coverage applies only to **dwelling buildings** and does not apply to personal property.

- **Actual Cash Value Coverage**. This option provides dwelling coverage on an actual cash value (ACV) basis. If there is a covered loss to the insured dwelling, the insurance company will pay either the **depreciated value** of the damaged dwelling at the time of loss or the **cost of repairing or replacing** the property with like construction, but only up to the policy's limit of liability. If ACV coverage applies, coverage for building code upgrades is not available.

- **Building Code Upgrade Coverage**. This option is available only if the replacement cost coverage option has been selected. Building code upgrade coverage, also known as **ordinance or law coverage**, provides up to $10,000 of coverage for the additional costs required to bring a damaged dwelling up to current building code requirements. Without this coverage, a policy would pay only the amount needed to **repair or replace** the damaged dwelling to restore it to the **condition it was in prior to the loss**, and would not cover any additional costs due to changes required by current building codes.

PREMIUM QUOTATIONS

In California, if a residence appears to be acceptable

on the basis of the application, a premium quotation will be issued by the FAIR plan. All premium quotations are dated. New business quotations are valid for a period of 60 days.

> A policy will be issued if the premium is paid within this 60-day period. If the premium is not received in the FAIR plan office within 60 days of the date of the quotation, the offer of coverage becomes null and void and a new application must be submitted.

To expedite putting coverage into effect, the FAIR plan issues **provisional quotations**. If the premium payment is made on time, provisional coverage will go into effect. If it is later determined as a result of an inspection that the property is **uninsurable**, the coverage will be terminated.

FAIR plan policies are usually issued for a term of **one year**. For new policies, the effective date of coverage will be:

- the date the premium quotation was issued, if the premium is received by the FAIR plan within 15 days of this date;

- the date the premium is received by the FAIR plan, if it is received after the initial 15-day period but within 60 days of the quotation date;

- any later date specified by the applicant following the payment of premium, pro-

vided that it is not more than 60 days af-
ter the quotation date.

Usually, a FAIR plan will accept or reject an applica-
tion within 20 days of receiving it. However, if through
no fault of the applicant the Plan fails to accept or
reject the application within that time period, the cov-
erage requested is deemed to be effective on the next
day after the date the application was received.

In order for this coverage to continue, the applicant
must pay a provisional deposit premium within 45
days after the date the application was received. If the
deposit premium is not received by the FAIR plan
within this 45-day period, no coverage is deemed ever
to have been effective and a new application must be
submitted.

PROPERTY INSPECTIONS

When a properly completed application is received by
a FAIR plan, the property becomes eligible for an **in-
spection**. Inspections are usually made **without charge
to the applicant**.

If anyone—an agent, inspector or other insur-
ance professional—tries to collect an inspec-
tion fee from you, call the nearest FAIR plan
office before handing over any money.

A FAIR plan makes inspections solely for **underwrit-
ing purposes** to determine whether the property is

insurable. It does not make **real estate appraisals** or guarantee that an applicant's property is safe.

The inspection will usually include, but need not be limited to:

- an examination of pertinent structural and occupancy features, and

- the general condition of the building and surrounding structures.

When the inspection is completed, the inspector will prepare a report and send it to the FAIR plan for evaluation.

> You—or your representative—have a right to be present during the inspection. You also have a right to request a copy of the inspection report.

An inspection report will note any **hazards or deficiencies** in the property. If repairs are needed, and coverage is not in effect, the offer of coverage may be made **contingent** upon making the repairs. If coverage is in effect, the FAIR plan may extend coverage for a **specified period of time** in which the necessary repairs must be made or else the coverage will be terminated.

If your property is found to be ineligible for coverage because of severe deficiencies, any coverage in effect will be canceled and you will be informed of what repairs are necessary or what deficiencies must be corrected in order to make the property insurable.

If any insurance is refused or canceled by the FAIR plan, you may submit **a new application** for coverage at any time after necessary repairs have been made or deficiencies have been corrected.

You have the right to **appeal** any act or decision of the FAIR plan which affects you adversely. Appeals of any decision—including rejection of a property for coverage—should be made to the Appeals Board or Governing Committee of the FAIR plan.

CANCELLATIONS

Policy cancellations requested by a policy owner will usually be canceled *pro rata* and will be effective on the date the request is received by the FAIR plan, unless a later date is specified.

If a FAIR plan policy is replaced with traditional insurance, the FAIR plan policy may be canceled *pro rata* upon receipt of proof of the other coverage. Flat cancellation is permitted only if requested prior to the thirtieth day of coverage following the policy effective date.

CONCLUSION

Assigned-risk insurance is an important tool in the lives of many who live in not only high-crime areas, but also other areas that are deemed as **high-risk** by insurance companies.

> Through the use of an assigned-risk pool or FAIR plan, you may be able to find a company that will agree to accept your risks and provide coverage for your home.

FAIR plan coverage is usually more limited than a standard homeowners insurance package—and the level of customer service is often not as high—but it's a welcome protection for people who don't have any other residential insurance.

CHAPTER **10**

HOW TO MAKE
A CLAIM

Insurance companies have fairly broad discretion in **paying claims.** One typical case from the early 1990s illustrates this point.

A San Francisco woman who had a homeowners policy with Fireman's Fund Insurance Co. reported that burglars stole $60,000 worth of personal property. The claim seemed suspicious to the Fireman's **adjuster,** who referred it to the company's **special investigations department.**

> Just before the claim, the woman had been notified that her policy was about to expire for non-payment of premium. She showed up at her insurance agent's office—in person—on the eve of the expiration date to pay.

Two weeks later, the agent received a report that the woman's home had been burglarized **the day before she paid the premium.** The woman claimed that her

losses included thousands of dollars worth of clothing.

Fireman's investigators knew that burglars **almost never steal clothing**—they concentrate on cash, jewelry, electronic equipment and other **portable or easily resalable** goods.

A Fireman's investigator interviewed the woman and created a file on the claim. However, in the **absence of clear proof of fraud**—and with a valid policy in effect—it seemed that the insurance company would have to make good on the loss.

The chief investigator recommended waiting a few weeks, so his staff could look into the claim more carefully. This kind of **delay was allowed** under the terms of the Fireman's Fund policy.

> An insurance company has the right and the option to investigate and settle any lawsuit and claim. It also accepts an obligation to defend any lawsuit or claim—but if it pays the limit of its liability to settle a suit or claim it is no longer obligated to provide any further defense.

More than a month later, the case still was not settled. The insurance company's investigators had discovered a few **complications**. Among these: the woman herself hadn't reported the burglary—a relative had. But there was a logical explanation. The woman had trouble writing English and needed the relative's help.

In its relevant points, her story checked out. "It looks like we're gonna pay [for the stolen clothes]," the chief inspector said.

This chapter will discuss the process of making a claim for the payments or benefits provided by the homeowners insurance contract in the event of an occurrence.

In the insurance industry, the process of **making a claim** and getting it paid is referred to as the **adjustment process**. It is a **negotiation**, in which knowing your rights can be pivotal. (This is something that holds true throughout the claim process.)

Example: If you present your circumstances effectively to the insurance company, its adjuster may allow an emergency purchase to go under your temporary living expense coverage rather than contents coverage. This kind of distinction—a technicality, really—can save limited coverage for crucial, permanent expenses.

YOUR DUTIES WHEN A LOSS OCCURS

If something happens that causes an insurable loss, the **duties required of you** as the policy owner are quite explicit. The policy states that you must:

- provide the insurance company with immediate written notice of loss;

- notify the police in case of loss by theft and a credit card or fund transfer card company in case of loss under Credit Card or Fund Transfer Card coverage;

- protect the property from further damage and, if repairs to the property are required, you must:

 1) make reasonable and necessary repairs to protect the property; and

 2) keep an accurate record of repair expenses;

- separate damaged and undamaged personal property and put it in the best possible order;

- furnish a complete and detailed inventory showing destroyed, damaged, and undamaged property, quantities, costs, ACV, and the amount of loss claimed;

- forward any legal papers received, such as a summons, to the company immediately, because there is usually a time limit for responding to such documents;

- within 60 days submit a signed proof of loss stating the time and origin of loss, the interest of all parties in the property, the presence of other insurance, the values of each item, and other information which the policy requires.

Also, the insurance company may request that you produce appropriate records, exhibit what remains of damaged property, and submit to examinations

under oath. You must comply with these requests "as often as may be reasonably required."

Your insurer will either send you a **proof of loss form** to complete or arrange for an **adjuster** to visit your home. In either case, you should document your loss as thoroughly as possible. If you prepared an inventory before the loss, this task will be easier.

A proof of loss report should set forth, to the best of your knowledge:

- the time and cause of loss;

- specifications of damaged buildings and detailed repair estimates;

- an inventory of damaged personal property;

- other insurance which may cover the loss;

- the interest of you and all other parties (mortgage companies, lien holders, etc.) in the property involved;

Losses are adjusted with and paid to you—unless the policy indicates payment should be made to someone else, such as a mortgage holder.

- changes in the title or occupancy of the property during the term of the policy;

- receipts for additional living expenses

incurred and records that support the fair rental value loss; and

- evidence or affidavit that supports a claim under the Credit Card, Fund Transfer Card, Forgery and Counterfeit Money coverage, stating the amount and cause of loss.

> **An adjuster may want to see all damaged items, so avoid throwing out anything after a loss has occurred.**

Whether your insurance company sends an adjuster or a proof of loss form, it's a good idea to **make a list** of everything that's been stolen or damaged as soon as possible. This list should include a **description of each item, the date of purchase, and what it would cost to replace** (if you have replacement-cost coverage).

Some **advance work** can held you fulfill these duties. Any relevant receipts, bills, photographs, or serial numbers from high-ticket appliances and electronic equipment will help establish the value of your losses.

> **Don't wait for a major loss to do this. You should keep a list that includes this information in a safe place at all times.**

The property inventory chart in Chapter 2 of this book should serve as a useful guide for assembling a list.

According to the **loss payable clause** of the standard policy, if you provide the proof of loss and other information—and the amount of loss has been agreed upon—the insurer will pay for the loss **within 60 days** (specific state laws may modify this time limit).

You must **assist the insurance company** in making settlements, making claims against other parties who might be responsible for the loss, be available for court trials, hearings, or suits, and give evidence as required.

PROPERTY VALUATION

Property losses under the basic homeowners or dwelling form are generally settled on an **actual cash value basis**. All forms support the principle of **indemnity**, which—in this context—means recovery may not exceed the smallest of four amounts:

- the ACV of the property at the time of loss,

- the policy limit for the coverage,

- the amount necessary to repair or replace the property,

- the amount reflecting the insured's interest in the property at the time of the loss.

When a loss is adjusted on an actual cash value basis, a deduction is made by the insurance company for the **depreciation** of the property. The term deprecia-

tion refers to the gradual reduction in the value of property as a result of time and use.

> **Example:** The original roof on a home is 10 years old when it is destroyed. The roof has an expected life of 20 years and has provided the owner with 10 years of service prior to the loss. If the loss is adjusted on an actual cash value basis, the company may pay the insured just half of the cost to replace the roof.

The **broad** and **special** forms provide **replacement cost coverage** for structures, but only if the amount of insurance on the damaged house is 80 percent or more of the full replacement cost of the house at the time of loss. And final recovery may not exceed the **amount actually spent** to repair or replace the property or the **policy limit** for the damaged house.

Replacement cost means to replace new up to the limits of the policy, less any deductible, with no reduction in the amount due to depreciation.

> **Example:** Following a fire in the kitchen of your home, the cost to restore the roof above the kitchen to its original condition is $700. If the insurance company assumes the entire amount of the repair cost (in this case $700), then you have had the loss adjusted on a replacement cost basis.

If you fail to carry coverage of at least 80 percent of the full replacement cost of the house at the time of loss, the insurance company will pay the larger of the following amounts (subject to the policy limit):

- the ACV of the **part of the house** damaged, or

- a **proportion of the cost to repair** or replace the damaged property equal to the amount the insurance coverage bears to 80 percent of the house's replacement cost.

If you and your insurance company don't agree about the value of a loss, your method of appeal is outlined by the standard policy. The insurance company states:

> If you and we fail to agree on the amount of loss, either may demand an appraisal of the loss. In this event, each party will choose a competent appraiser within 20 days after receiving a written request from the other. The two appraisers will choose an umpire. If they cannot agree upon an umpire within 15 days, you or we may request that the choice be made by a judge of a court of record in the state where the [house] is located. The appraisers will separately set the amount of loss. If the appraisers submit a written report of an agreement to us, the amount agreed upon will be the amount of loss. If they fail to agree, they will submit their differences to the umpire. A decision agreed to by any two will set the amount of loss.

From time to time, policy owners bring suits against their insurance companies when they are dissatisfied over claim adjustments. Before this can be done, you must comply with the **policy provisions** concerning the reporting of the loss, cooperating with the company in settling the loss, etc.—and any suit must be brought **within one year** after the loss.

The 1990 Louisiana state appeals court decision *Dwight and Phyllis Sayes v. Safeco Insurance Co.* shows how hotly a loss valuation can be disputed.

In February 1988, the Sayeses purchased a homeowners policy from Safeco to insure a house which they owned. In March, the house was severely damaged by fire, although not totally destroyed. In May, the Sayeses furnished a proof of loss form to Safeco which totalled $37,888.61—the estimated cost of repairing the damage.

Safeco paid the Sayeses $21,875.53, the **depreciated**— or **actual cash value**—of the damaged property. It contended that, under the terms of the policy, the balance of the loss was not payable until the property was actually repaired.

The Sayeses filed suit against Safeco to collect the difference between the actual cash value and the replacement value.

The trial court agreed with **Safeco's interpretation** of the policy.

The Sayeses appealed, arguing that they were entitled to the full replacement—as well as attorney fees and other expenses. In their appeal, the Sayeses pointed

to a section of the policy titled **Option A—Home Replacement Guarantee**. In this section, Safeco stated:

> We will settle covered losses to the dwelling...without regard to the limit of liability [if] you agree to:
>
> 1) insure the dwelling to 100 percent of its replacement cost as determined by us,
>
> 2) accept any yearly adjustments by us...reflecting changes in the cost of construction for the area,
>
> 3) notify us of any addition or other remodeling which increases the replacement cost of the dwelling $5,000 or more...and,
>
> 4) repair or replace the damaged dwelling.

The Sayeses had complied with the conditions. They argued that, under this optional coverage, they were not required to repair the damaged dwelling before payment of the estimated repair cost was due. They were only required **to agree to make such repairs**.

The judges on the appeals court ruled:

> If we accept Safeco's interpretation of the policy, because [the Sayeses] have not yet repaired the damaged dwelling...they have not complied with Option A...and, therefore, payment is not due until after the actual repairs are made. Safeco's reasoning is circular and, under their interpretation of the policy, both the General Conditions and Option A would require that actual repair of damages be made before payment is due for a covered loss.

> We think, at a minimum, the insurance policy is ambiguous. Option A applies if [the Sayeses] "agree to...repair or replace the damaged dwelling." It does not say that it will only apply, if [they] actually make repairs to the damaged dwelling....

Because the policy was ambiguous as to whether the repairs had to be made before payment or whether they could be made afterward, the policy had to be interpreted against its drafter, Safeco.

Whenever language in an insurance policy is ambiguous, any dispute over coverage is ruled in favor of the policy owner. The insurance company has its opportunity to set terms in the drafting of the policy.

OTHER DWELLING AND PROPERTY CLAIMS ISSUES

In most instances, insurance companies settle claims by **making payments** to the policy owner. However, they have the option of **repairing or replacing property**. This will occur when replacement can be made at a cost to the company which is less than that which the insured could negotiate.

Payments known as **up-front payments**—which include temporary living costs and other incidental costs paid in advance—are voluntary to the insurance company. A company can require you to incur the expenses first and be reimbursed later.

> Example: A fire occurs at your home and the damage is so extensive that the house can't be lived in until repairs are made. You rent rooms in a motel and take all your meals in restaurants. Services you provided for yourself, such as laundry, must now be provided by others at a greater cost. Additional living expense will pay the additional cost of living over and above your normal costs for housing, food, laundry, or other expenses.

The **pair and set clause** in the standard policy recognizes that the loss of one item from a pair or set may reduce the value of a pair or set by **an amount greater than the physical proportion** of the lost item to the set. It usually comes into play when items of jewelry, fine arts or antiques are involved.

> Example: A pair of antique candelabra is valued at $3,000. One of the sticks is stolen in a burglary. The value of the one remaining is established at $1,200—so the value lost is $1,800. This would be the amount of the loss. If the missing candelabra could be replaced for $1,700, then the company has the option of making the replacement.

In many cities there are **ordinances** that require that sliding glass doors or tub and shower enclosures, if broken, are to be replaced with safety glass. If that's

the case where you live, the insurance company will usually cover any additional cost these rules add to a claim.

An **abandonment clause** prohibits you from abandoning property to the insurance company in order to claim a total loss. Although the company may **choose to acquire** damaged property which can be sold for salvage and may choose to pay a total loss, you cannot insist that the insurer take possession of any property.

Example: You have a loss due to a fire in your garage. Most of the contents are damaged, but some are not. You can't tell the insurance company, "There was $4,000 worth of stuff in the garage. Pay me $4,000 and the contents of the garage are yours." The company will usually not accept this kind of a proposition because it has to make arrangements for hauling, repair, and sale of the salvageable property and it does not care to do this.

If property that has been stolen and paid for by the insurance company is **recovered** later on, you can elect to take the property and pay back the insurance company the amount it originally paid for the loss. An alternative is to keep the money and let the company keep the property.

Despite the specified amount of insurance, a policy owner's **insurable interest** may limit the amount paid on a claim. Other parties may have an insurable interest in your property as an owner, mortgage holder, vendor, lien holder, stockholder, joint owner, bailee, or lease holder.

Once an insurance company has paid you for the loss

you sustained, it acquires your rights in the claim. This transfer is called **subrogation**.

> **Example:** Your neighbor loses control of his car and crashes into your garage. Your insurance company, after paying you, now has the right to sue your neighbor to collect from him the amount it paid to you. Once you receive payment, you "subrogate," or pass on, your rights in the claim to the insurance company.

LIABILITY CLAIMS ISSUES

Medical payments paid by your insurance company to third parties injured while on your premises are **voluntary** and are **not to be construed as admitting liability** should the injured party bring suit at a later date.

The insurance company **can't be joined in a lawsuit** against you by an injured third party, since the company is not involved in the occurrence which results in a suit. Furthermore, the company has no obligation to make any payment under liability until a **final judgment** has been rendered or the company has agreed to settlement of the claim.

If you become **bankrupt or insolvent**, the company remains obliged to provide coverage and to respond to the terms and conditions of the policy.

Your homeowners policy may include the following language: "With respect to the personal liability cov-

erage, this policy is excess over any other valid and collectible insurance."

The practical application of this clause varies, depending on the other insurance. Duplication of coverage often ends up with both insurance companies contributing to payment of a loss.

> The other insurance clause doesn't apply to so-called true excess liability insurance—like standard umbrella liability policies. Umbrella policies remain a secondary form of insurance to a homeowners policy.

THINGS YOU CAN DO TO STRENGTHEN CLAIMS

Reading your policy is very important. If you know what kind of coverage you have, you're more likely to receive all you're entitled to. The following is a list of factors to double check:

- **Keep careful records.** Make copies of all information you give your insurer in connection with your claim. And be sure to hold onto everything the insurer gives you. It's also a good idea to take notes of all meetings and conversations you have with your agent, insurer, or claims adjuster.

- The **seemingly trivial details** of your homeowners policy—and the way you

handle the insurance adjustment process—can determine whether you come out of a disaster financially whole. Time and coverage limits, co-insurance clauses and the vagaries of actual cash value versus replacement value can cost you thousands of dollars. Don't overlook any part of the claims process.

- **Verify the adjuster's estimate.** Before you accept a settlement for repairs to your home, it's wise to get a written bid from a licensed contractor to make sure the adjuster's estimate is realistic. You could also bring in a public adjuster (one who is not affiliated with any insurance company) to make an estimate. The public adjuster would then negotiate with the insurer's adjuster for you. Public adjusters may charge fees of up to 15 percent of the final settlement.

Before you enlist the help of any outside experts, be certain to check their qualifications with your state department of insurance or the local builders association.

- **Don't settle for an unfair settlement.** If you can't reach an agreement with your adjuster, contact your agent or the insurer's claim-department manager. If you're still dissatisfied, some state insurance departments offer mediation services. In addition, most policies allow for

an independent appraisal or arbitration process to resolve disputes over money. That decision is usually binding.

The amount of **temporary living expense** you can expect usually depends on what you've lost. Policies normally cover the cost of **renting a comparable home or apartment.** If you can figure out what the rental value of your home was, that's usually the amount you can get reimbursed for renting another place.

Temporary living allowances will also pay for **extraordinary expenses** caused by your displacement. These often include boarding a pet in a kennel, renting furniture and eating at restaurants while you're living in a hotel or motel.

Insurers won't pay **ordinary living expenses** such as groceries, regular evenings out or ordinary utility bills.

Some insurers limit temporary living expense payments either by a **dollar amount** or a **time period.** Some insurers limit by both time and dollar amount. Others have no limitations.

If you are not getting enough payment to cover your temporary living expenses you can request more. But it helps if you're prepared to give reasons. For instance, you know it's going to cost $3,000 to pay a deposit and the first month's rent on a comparable home. And you can reasonably expect to spend at least $1,000 replacing enough clothing, shoes and personal items to get by for a few months.

If you're in a crunch for rebuilding money, you may disregard any **replacement cost loss settlement pro-**

visions and make a claim under the policy for loss or damage to buildings on an **actual cash value basis** (the ACV will usually be a lower amount). You can then make a claim within 180 days after loss for any **additional losses** according to the replacement cost provisions.

Example: Your house is severely damaged in a covered accident. You plan to rebuild, but you're going to use a different floor plan. You can collect the actual cash value amount after the loss. Once you've decided exactly what the rebuilding will involve, you can collect additional amounts on the basis of replacement cost so long as a claim is made within 180 days of the date of loss.

CONCLUSION

If you have chosen your insurance effectively, making a claim will be pretty straightforward. Of course, the circumstance that lead up to making a homeowners claim—burglary, fire or other disasters—can make even the most calm mind nervous and edgy. This chapter has focused on the effective measures to take from reporting an accident to choosing the right claim adjuster.

In Chapter 11, we will discuss the common problems regarding coverage and the ways to avoid these problems.

HOW TO
AVOID COMMON
COVERAGE
PROBLEMS

Many situations can cause problems with a policy or a claim regarding homeowners insurance. When shopping for homeowners insurance, it's a good idea to anticipate these problems as fully as possible—and avoid them.

> Most disputes between insurance companies and policy owners center on coverage issues—whether or not a particular loss is insured by a policy. The main mechanism insurance companies use to protect themselves against the negative financial impact of big claims is to deny coverage on some fundamental issue. This usually means an issue not related to the specifics of the claim.

Understanding the concepts behind these problems is an essential tool to finding the right insurance solution for you. This chapter will explore the common problems involved with coverage and provide you with the knowledge to avoid these problems.

FUNDAMENTAL COVERAGE ISSUES

One fundamental coverage issue is a matter we've explored before—**insurable interest**. This issue has to do with who has the right to make a claim on the proceeds of a policy.

Following the 1994 Northridge earthquake, California mortgage lenders, insurance companies and homeowners were locked in a battle over earthquake insurance claims.

Many insurance companies, instead of paying claims directly to homeowners, make out checks with mortgage lenders as **co-payees**. The lenders, in turn, are reluctant to sign over earthquake insurance claims until homeowners prove that rebuilding has begun.

However, most homeowners couldn't begin to rebuild until they collected money from the insurance company. This created a gridlock that kept rebuilding from proceeding.

The California Department of Insurance warned insurance companies that forcing homeowners to get lenders to sign claims was illegal. But insurance companies argued that mortgage lenders with an insurable interest in an insured dwelling had to be treated as co-payees.

Some consumer advocate groups argued that the complication was an intentional tactic used by insurance companies to delay paying earthquake insurance claims.

As might be expected, insurance companies denied any intentionality. Some individual companies expedited payments. But processing earthquake claims did take longer in the wake of the Northridge quake than many policy owners expected.

If a covered loss causes damage in such a way as to expose an insured dwelling to **further damage**, the policy owner has an obligation to make **reasonable repairs** or to take other steps to protect the dwelling or any property.

Example: If a windstorm blows away a portion of your roof, the policy would pay for—and actually require—temporary repairs to the roof to avoid further damage to the interior of the structure. If you don't make the reasonable repairs, the policy won't cover the further damage.

Likewise, the standard policy allows the policy owner to move property from a premises threatened by a covered peril to a place of safety for a period of 30 days. The removed property is covered during the moving and at the other location for loss from any cause—which expands coverage considerably.

On the other hand, if the policy owner doesn't take the opportunity to remove personal property, the in-

surance company might interpret this as failure to reasonably protect property from damage.

> Disputes related to issues of failure to protect a dwelling or property usually occur in combination with disputes related to specifics of a claim. You might not expect this kind of thing to be what determines your dispute—but you might be surprised when you go to trial. Courts put a lot of weight on failure to prevent further damage.

Insurance companies that are looking for a reason not to pay a claim may try to expand a dispute over prevention into a dispute over **policy owner neglect**—which is explicitly excluded from coverage.

Charges of neglect quickly turn back to the phrase **reasonable means** of prevention. Some insurance companies interpret it to mean that you should do the same things to protect the property that you would if there were no insurance coverage on the property. But not all courts agree with this definition.

Another important factor to many insurance companies is how the **expiration of a policy** affects coverage. The easiest way to deny a claim is to show that the policy wasn't in effect when the loss occurred.

Of course, the issues aren't always so clear. If a loss occurs **just before the expiration date** of the policy and **continues** for two months afterward, the loss

would be fully covered. However, a dispute could arise over when—exactly—the loss first occurred.

Example: You make a claim that, because of an insured flaw in the construction of your house, a series of accidents began during a policy's coverage period and has continued afterward. If the insurance company can show that the loss didn't begin and continue—but is, in fact, several losses occurring independently—it can limit its liability to claims that relate to accidents that occurred during the policy period.

Other issues that affect the term of a policy—and, therefore, any claims made—are **cancellation** and **nonrenewal**.

The standard homeowners policy describes at length how and when a policy can be canceled:

You may cancel this policy **at any time** by returning it to us or by letting us know in writing of the date cancellation is to take effect.

We may cancel this policy **only for the reasons stated below**....

When you have **not paid the premium**, we may cancel at any time by letting you know at least 10 days before the date cancellation takes effect.

When this policy has been **in effect for less**

than 60 days and is not a renewal with us, we may cancel for any reason by letting you know at least 10 days before the date cancellation takes effect.

When this policy has been in effect for 60 days or more, or at any time if it is a renewal with us, we may cancel:

If there has been a **material misrepresentation of fact** which if known to us would have caused us not to issue the policy; or

If **the risk has changed substantially** since the policy was issued.

...When this policy is written for a period of more than one year, we may cancel **for any reason at anniversary** by letting you know at least 30 days before the date cancellation takes effect.

The insurance company is only allowed to cancel a policy for a few reasons in order to prevent it from canceling because a policy owner has made claims.

The most common cancellation dispute occurs when a policy owner claims that the insurance company has canceled the policy under false pretense. That is, the company points to one of the allowed reasons but is actually canceling because it doesn't want to pay a legitimate claim. This is a difficult charge to prove.

The same issues are raised by nonrenewal, which is a

slightly less abrupt version of cancellation. When an insurance company elects not to renew a policy, it simply waits until some period (usually 30 days) before the expiration date and informs the policy owner—in writing—that it doesn't want to continue the insurance.

> If you receive a nonrenewal notice, you should get another policy lined up as soon as possible and be very careful about documenting any losses that occur during the remaining policy period. If you make a claim, you may have some problems getting it paid fully.

Beyond the handful of fundamental issues, most coverage disputes focus on three kinds of issues—all related to the specific details of a given claim. The three kinds of issue are related to: dwellings and structures, personal property and policy exclusions.

DWELLING AND STRUCTURE ISSUES

With respect to the dwelling and other structures, the standard homeowners policy says that it covers any **direct loss**. Unfortunately, this definition can prove problematic. For instance, it doesn't apply to certain losses that you might think of as being direct. The following are some exceptions:

- structural **collapse** is only covered to the extent of certain provisions;

- losses resulting from **freezing** while a dwelling is unoccupied are covered only if an attempt has been made to maintain heat in the structure or if the water supply has been shut off and plumbing, heating, air conditioning and interior sprinkler systems have been drained;

Example: You live in Maine, but during the height of winter each year you spend several months in Florida. If the plumbing system bursts due to freezing and leakage causes damage to your house, there will be no coverage. However, if you drain the plumbing and shut off the water supply—or you provide heat in the building—there will be coverage.

- certain **outdoor structures**—such as pools, decks, gazebos, etc.—are not covered for damage by freezing, thawing, pressure, or weight of water or ice;

However, losses to certain types of property usually located outside the building are covered if caused by collapse. **Example:** A fence collapses, damaging the cesspool which is located beneath it. Coverage would apply to the fence and the cesspool.

- theft of **materials or supplies** used or for use in construction of a dwelling is not covered (this includes such items as lumber and other building materials; pipe, and fixtures whether installed or not);

- there is no coverage for **vandalism** if the dwelling has been vacant for a period of over 30 days.

> Vacant means that there is no one occupying the dwelling and the dwelling is not furnished. A dwelling that is furnished but not occupied temporarily, such as when the owner is on vacation, is not considered vacant.

All of these issues can result in legal disputes between policy owners and insurance companies. The best way to avoid the disputes is to be forewarned. Other than that, you'll need to prove that the exception happened concurrently with a covered direct loss.

Most local building codes contain provisions relating to the demolition and rebuilding of a damaged building. These can require an older house to be repaired **up to code**—that is, to modern building standards. A standard homeowners policy will only cover the additional cost of building up to code if you pay an additional premium.

> Example: If your vintage 1920s villa is partially damaged in a covered loss, local laws may require an upgrading of the electrical or plumbing systems. This may mean the use of costlier building materials or methods. The increased costs for the repairs aren't usually covered by a basic policy.

The best way to avoid this problem: If you have an older home, buy additional coverage.

Finally, a number of conditions can cause damage to a dwelling but are not covered since they are caused by **ordinary or excepted conditions**. A few of these conditions are:

- **wear and tear**, marring, and deterioration come under depreciation due to age and are not covered;

- **inherent vice** is the ability of something to destroy or damage itself without the intervention of outside help;

> Example: Milk will sour in a sealed container and under refrigeration due to bacteria contained in the milk. Rusting of metal is not inherent vice since it is the product of a ferrous metal being exposed to air.

- **rust, mold, dry rot, and wet rot** are the

result of property being exposed to harmful conditions over a period of time and can result from lack of, or improper, maintenance and therefore are not the property subject of coverage;

- **industrial smoke, agricultural smudging or smog** can certainly damage property over a period of time but, if coverage were provided for these maintenance losses, many homeowners would never have to pay for having their homes painted;

- **settling, cracking or bulging of pavement,** foundation, walls, floors or ceilings are also considered maintenance losses;

- damage caused by **birds, vermin, insects, rodents, or domestic animals** is not covered.

An important element of the vermin and insect exclusion is damage caused by termites. This isn't covered. That's one reason why it's important to control pests in any house you own.

PERSONAL PROPERTY ISSUES

Specific types of **personal property**—and not always the types you would expect—cause lots of coverage disputes between policy owners and insurance companies. The following are a few illustrative examples of these kinds of property and the disputes they cause.

Trees, plants, and shrubs are covered under a standard policy only against a few named perils—and only if they are on the residence premises. There is a per loss limit and a per item limit. The per loss limit is 5 percent of the amount of coverage on the dwelling and the per item limit is $500 per tree, plant, or shrub.

Policy owners will sometimes spend more on plants than they initially figure—and try to make a big claim after a loss. If you spend money on flora, you may need to consider an endorsement that increases this coverage.

The homeowners policy provides up to $500 coverage for **lost or stolen credit cards**—even though federal law limits the liability of the card holder to $50 per card. The policy also covers the unauthorized use of the cards.

However, coverage does not apply to the use of the card by a resident of your household, a person who has been entrusted with the card, or the use of the card by any person if you have not complied with the terms and conditions of the card—such as exceeding the credit limit of the card.

Similar coverage is provided for bank cards used with automatic teller machines that are taken from the home. **Check forgery** or forgery of any negotiable instrument is covered under this provision. This can be an important issue if thieves steal blank checks from your house.

> If you have credit card theft or check forgery
> problems involving members of your house-
> hold, you can't make claims on your
> homeowners policy. Some people try this—but
> they aren't usually successful. If you suspect
> problems with family members, limit access to
> your financial instruments and have systems
> in place for canceling cards and checks if nec-
> essary.

Other provisions exclude property losses arising out
of **business pursuits.**

Common coverage problems also arise from **member-
ship in homeowners or community associations.**

Loss assessments against **individual members** of prop-
erty owners associations are not usually made unless
the insurance covering the collectively owned prop-
erty (e.g., the clubhouse, other outbuildings) does not
cover the loss involved or is not in sufficient amount
to entirely cover the loss.

When this occurs, assessments can be made if the by-
laws of the organization allow them. If this is the case,
the policy will pay up to $1,000 per loss.

> A caveat: Loss assessments against members
> for liability claims made against the associa-
> tion are covered separately under the liability
> sections of the homeowners policy.

A standard policy will cover property owned by an insured person and kept in a separate apartment **on the residence premises** that is rented out on a regular basis. However, property in a rented apartment **off the premises** is excluded.

GENERAL EXCLUSIONS AND OTHER ISSUES

The **general exclusions** to a standard homeowners or dwelling policy limit coverage for the perils of ordinances or **laws, earthquake, flood, power interruption, neglect, war** and—in a reference to the days of the Cold War—**nuclear hazards**.

These exclusions cause many disputes between policy owners and insurance companies—especially when the company interprets a claim as based on an excluded peril and the policy owner sees it as something else.

A complicated note: An excluded loss which is caused by a covered peril is covered.

Example: You're away from home for a week of skiing, but you maintain the radiant heating in your home while you're away. Squirrels eat the insulation around the electrical wiring, which causes a short circuit cutting off the electricity. As a result, the plumbing system freezes and bursts in several places, causing severe water damage. While the damage by rodents would not be covered, the resulting damage by water would be covered—because you had complied with the requirement to maintain heat in the building while it was unoccupied. The water damage was an ensuing loss.

There is no coverage for damage to the contents of a dwelling or other structure by **rain, hail, sleet, sand, or dust** unless the dwelling first is damaged by wind or hail allowing rain or dust to enter the building and damage the contents. A simple leaking roof due to wear and tear is not covered.

Likewise, coverage on personal property within a structure is provided with the condition that the roof or a wall of the structure is damaged first by a **falling object**.

> **Example:** If a utility pole falls on your house, smashes through the roof and destroys your brass bed, the bed is covered.

Severe storms can cause the accumulation of the various forms of frozen water on a roof and the weight will eventually become so great that the roof will collapse. If this causes damage to the contents, those contents would be covered.

The disputes that arise from these **sequential loss** scenarios usually center on the insurance company not believing that the loss occurred sequentially, as described. Primary evidence of the loss—such as videotapes or photographs—can substantiate this kind of claim. An affidavit from a neighbor who saw what happened—or any other witness—will also help.

There is no coverage at **another residence** owned, rented to, or occupied by an insured person unless that person is temporarily residing there. So, coverage doesn't apply to your summer house unless you're staying there.

> People will sometimes bend the truth in claiming they were living in a second home when a loss occurred. Like other misleading statements, this kind of thing can cause more trouble than the coverage it allows. In most cases, it makes more sense to buy a basic dwelling policy for a second home.

Coverage is provided for a student away from home if the student has occupied the premises at any time 45 days prior to the loss. Anecdotally, many people seem to claim they meet this requirement—that the student who's suffered a loss has been home recently—even when they don't. They seem to get away with claiming this.

There is no theft coverage for boats, their equipment or furnishings, or outboard motors while away from the premises. There is coverage for other personal property, such as clothing, if stolen from a boat.

Trailers and campers are, likewise, not covered for theft while away from the residence premises.

The disputes that usually follow from these claims turn on the issue of where the boat or trailer was when a loss occurred. Location can be difficult to establish—which usually works for the person making a claim. Unless the insurance company can prove the property wasn't on premises, it will probably have to pay the claim.

Claims related to the **accidental discharge or overflow of water or steam from appliances** can cause some problems. These claims are covered under a standard policy—with the following exceptions:

- the drain of a washing machine malfunctions causing an overflow of water—the damage done by the overflow to personal property is covered but there is no coverage for repairing the washing machine;

- several rooms of a dwelling are closed off

during the winter to conserve heat and the lack of heat in these rooms causes a pipe to freeze and rupture—there is no coverage for the ensuing water damage;

- a pipe on the side of your neighbor's house bursts and water flows into your basement recreation room, damaging the contents—there is no coverage.

Some adjusters—especially in the Northeast and Midwest—pride themselves on ferreting out abuses of water damage in houses. You are most likely to have a problem with this kind of claim only if you end up drawing one of these adjusters.

Several other causes of water damage are also not covered by the standard policy. These include:

- natural accumulations of water on the ground, overflow of natural bodies of water, or waves;

- backing up of sewers or drains as the result of an overload of the sewage or drainage system, or the blockage of such systems; and

- water which percolates or seeps underground and usually involves damage to property below ground level or structures on the ground such as sidewalks and driveways or concrete slabs.

> If a direct loss by fire, explosion, or theft oc-
> curs because of water damage losses, cover-
> age is provided. So, if a backed-up sewer
> causes an electrical relay station in your
> neighborhood to explode and your house
> catches fire as a result...you're covered.

The standard homeowners policy excludes coverage for damage caused by **earth movement**—which includes earthquakes, land shock waves and tremors. It also excludes coverage for **volcanic eruption**.

Volcanic eruption is not defined in the policy as clearly as earth movement is. However, the two perils share many characteristics. In the Mount St. Helens eruption, several things happened: The explosion created airborne shock waves and land shock waves; there were various tremors; and huge amounts of dust were blown into the air which settled over vast areas causing damage and creating cleanup situations.

Earth movement can occur in a number of ways, such as earthquake, mine subsidence, sinkholes, or the collapse of a palisade. This peril is excluded except for resulting direct loss by fire, explosion, theft, or breakage of glass. And this exclusion holds up in most disputes.

This exclusion is illustrated well in the 1994 case of a Santa Monica, California, couple who thought they had insured their multimillion-dollar art collection and filed a lawsuit against a local insurance agency and a giant insurer for failing to pay a $2.5 million claim for earthquake damage.

Gary and Donna Freedman alleged bad faith and breach of contract on the part of American Business Insurance Brokers Los Angeles Inc., for selling them an all-risk policy for their collection of paintings and ceramics through Fireman's Fund Insurance Co.

After fifteen pieces of their collection, including a $2 million Roy Liechtenstein oil painting, were damaged during the Northridge earthquake, the Freedmans made a claim. Fireman's Fund denied it, on the grounds that the policy excluded earthquake damage.

Gary Freedman said he was only told by his broker that an amendment had been added to his policy excluding earthquake damage after he'd made his claim. American Business said it discovered a copy of the amendment to the 1992 policy in its files only after the dispute erupted.

"We don't have such an exclusion in our copy of the policy and, even if we did, one was never issued with the 1994 policy," said an attorney representing the couple.

The Freedmans wanted $2.5 million in actual damages plus an unspecified amount of punitive damages. "You're thinking, thank goodness I have insurance for my valuable possession," Freedman said. "Then to be told that you don't...it's a big loss."

The purpose of the **war exclusion** is to remove from the policy even the most tenuous possibility of coverage for any loss due to warlike activity or its consequences. However, the related exclusion of **terrorist action**—which has begun to appear in most policies in recent years—may cause a growing number of disputes in the future.

Unfortunately, if terrorist attacks become more common in the United States, companies will probably expand their exclusionary language for this risk. As a policy owner concerned about this risk, your only choice will be to pay more for additional coverage.

A final note: If losses resulting from the general exclusions occur with perils that are covered under the policy—either together at the same time or in a prior or later sequence—there will be no coverage.

> **Example: If an earthquake causes pipes to burst and cause water damage to the furniture in your living room, you're not going to have an easy time making a claim. Although water damage is ordinarily a covered peril, because it occurs in connection with earthquake (a general exclusion), it is not covered.**

CONCLUSION

The possibilities are endless for problems that occur in a homeowners policy or claim. Hopefully, we've given you enough information to avoid not only the problems we mentioned, but also to distinguish and avoid other common grounds for dispute.

Knowing how to approach handling a claim and an insurance company's reaction is key to avoiding misperceptions and confusion that arise in a dispute.

A smart way to avoid these problems is to read the policies closely when determining what homeowners insurance to purchase. The next chapter will provide helpful hints for comparing and purchasing your homeowners policy.

CHAPTER 12

TIPS FOR SMART BUYERS

When Hurricane Andrew slammed into the Florida coast in August 1992, Brian Pariser's home was one of more than 135,000 damaged or destroyed. Pariser believed his home was fully covered—until a contractor told him it would cost $165,874 to rebuild. That was $62,445 more than his insurance policy would pay.

"What angered me most," Pariser told a local newspaper, "is that I had asked my agent for the best possible coverage."

In 1981, he'd bought a homeowners policy, that had been an HO-3 policy. But, in the years since, his insurance company had introduced **guaranteed-replacement-cost** policies. To add insult to injury, these policies were available to many homeowners at lower premiums than standard HO-3 insurance.

Pariser, and other homeowners who claimed they only learned about the better coverage after Hurricane Andrew, complained bitterly that guaranteed replacement-cost policies were offered as a matter of course

to new policy owners—but long-term customers were left uninformed.

In fact, a group of them filed suit against several large homeowners insurance companies, arguing that the companies had been negligent in not telling their customers about better coverage.

Of course, they could have asked their agents or insurance companies if there were newer, broader policies available.

By now, you have probably gathered a working knowledge of many of the concepts and problems that go along with your homeowners insurance policy. This chapter—which brings the book to a close—reviews some basic buying guidelines and tips that smart insurance consumers can follow to maintain cost-effective coverage on their homes.

COMPARING POLICY TERMS AND CONDITIONS

It's no brilliant conclusion to say that insurance consumers—like consumers of anything—should compare the various products they're considering buying. The problem with insurance is that people don't always know where to look.

When considering the right insurance policy to buy it's important to know the replacement value of your home—and how insurance companies calculate this figure.

You should have enough insurance to cover the cost

of rebuilding your home. This may be different than the **market value** or **assessed value**—that's why the most popular policies currently are the ones that guarantee replacement value. They eliminate the homeowner's risk of being caught short.

> Some homeowners get into automatic insurance packages that limit homeowners coverage to the amount they owe on their mortgages. If you have that kind of insurance—and especially if you've paid off a good part of your loan—take some time to review its coverage. It could mean if something bad happens, your mortgage company will be paid off but you'll be left with a vacant lot where your house used to be.

Always buy insurance for **at least 80 percent of your home's replacement value.** If you buy less, you forfeit the right to collect the full replacement value of the insured property, even for a partial loss.

Replacement cost coverage is subject to three **price factors**, which put limits on the amount of recovery. It is important to consider these factors when purchasing your policy:

- the loss payment shall not exceed the **limit of insurance** on the building,

- the loss payments shall not cover any more than the cost of **similar construction**, and

- in no event shall the loss payment exceed the **actual cost of repair**.

You can raise or lower the other coverages a standard homeowners policy offers to meet your particular needs.

Most policies cover **personal property** for 50 percent of the insured value of the house. So, if your house is covered for $100,000, the insurance company will pay up to $50,000 for loss or damage of its contents. For a higher premium, you can increase that coverage to 75 percent.

Most policies do not cover damage to—or loss of—cars, aircraft, or pets. For some items, there are limits to coverage for theft. Those vary somewhat from company to company, but the following limits are typical:

- $3,000 on computers;
- $2,500 on silverware;
- $2,500 on firearms;
- $2,500 for business property kept at home;
- $1,000 to $2,000 on jewelry, watches, and furs;
- $1,000 on securities, deeds, manuscripts, and other valuable papers;
- $1,000 on boats; and
- $200 on coin collections, gold, silver, and currency.

These limits apply to each category of item, not each item. You can buy additional insurance to raise the limits on any of these categories or to protect specific valuables.

Inflation-guard clauses written into policies ostensibly protect the homeowner against rising construction costs, yet many storm and fire victims find that these clauses fail to keep pace with the market.

A caveat: Construction prices can jump even higher after a major disaster—like a hurricane or earthquake—when building materials and labor are in short supply.

Owners of older homes often fare the worst with inflation-guard policies—and even guaranteed-replacement-cost policies. These adjustment mechanisms don't usually cover the expense of upgrading older homes to meet current building codes.

An estimated 50 percent of the homes damaged or destroyed in the California's Oakland Hills fire were code-deficient. Most of these people had to battle their insurance companies for what they considered standard coverage—and bring their rebuilt houses up to code.

If you own a house that's more than 20 years old, you may need to buy additional coverage that assures any rebuilding will bring the house into compliance with current codes and zoning laws.

KEEPING COSTS DOWN

Premiums are based on property value, type of construction, location, etc. When comparison shopping, keep in mind that there are many ways to reduce the amount of premium that you pay for your homeowners insurance policy.

Before purchasing your home and the insurance for it, take into account the types of construction and your location. The cost for wood-frame construction ranges from $1.50 to $3.00 per $1,000 of coverage, depending on location. Lower rates apply in the central part of the state; higher rates in the coastal counties and those along fault areas. Residents of areas with traditionally high losses—from crime, fires, or natural disasters—can expect to pay more than residents of low-loss areas.

Buy a combination of two or more types of coverage, or "package policy." The Homeowners Policy Program provides liability automatically in addition to the property coverages. By combining property and liability coverages, the insurance company is able to reduce processing costs, determine losses more accurately, and pass these savings on to the consumer in the form of lower premiums.

For most homeowners forms, a **principal amount** of insurance is selected for the dwelling. Reasonable amounts of coverage are then automatically provided for **other coverages** based on a percentage of the amount provided for the dwelling.

These **reasonable amounts** are not the maximum amounts available, they are simply limited amounts of coverage that satisfy the average needs of most homeowners. If a particular person has a greater exposure, greater amounts of insurance may be purchased.

Example: You have $10,000 of coverage for other structures based on the amount of insurance written for your dwelling. If your four-car detached garage has a replacement cost of $30,000, you may need to purchase more other structures coverage—in which case, an additional premium will be charged.

Under HO-4 and HO-6, the principal amount of insurance is selected for personal property—and a reasonable amount of coverage is automatically included for other coverages, based on a percentage of this amount.

A few other tactics that can help keep down premiums:

- **Raise your deductible.** The higher your deductible, the lower your premium. If you raise the deductible from $250 to $500, you may be able to trim more than 10 percent off your premium. Raise it to $1000 and you could save more than 25 percent.

- **Ask about your fire-protection class.** The closer you are and the better the professionals are trained, the lower your premiums should be. The Insurance Services Office assigns every neighborhood in the U.S. a fire-protection class, based on the quality of fire protection and the distance of homes from a water source. (Some companies may use their own rating systems.) If your assigned class isn't right, you may be paying too much for your insurance.

- If you're having difficulty obtaining insurance in the standard market, you may want to **look into a FAIR plan policy.** FAIR plans were created to make basic property insurance available to consumers in areas where coverage is difficult to obtain or has become otherwise unavailable. The FAIR plan writes coverage in designated urban areas and hazardous brush areas. The federal government provides riot reinsurance for insurers that participate in a HUD-approved FAIR plan.

Any person having an insurable interest in property in an officially designated area who has been unable to obtain coverage through normal channels is entitled to FAIR plan coverage.

REVIEW COVERAGE EVERY FEW YEARS

One of the most important things to consider regarding your homeowners insurance is not to assume that everything has been taken care of—or that it has been taken care of in the best way for your needs.

If you rely on your insurance company or agent to set your policy limits and to keep those limits updated, you may find yourself **underinsured** when you file a claim. This can be a serious problem. In extreme situations, you can deal with underinsurance by having your policy upgraded retroactively. But this kind of solution is rare—and getting rarer, as insurance companies operate on ever-thinner reserves and profit margins.

The fact remains that, if you haven't reviewed your homeowners policy in the last few years, your home may be underinsured. The house you insured for $115,000 five years ago could cost $150,000 to rebuild today. Any additions, renovations, or major purchases could also have boosted your coverage needs.

Also, if other assets you own have grown substantially, your personal liability limits should be adjusted to keep up with them.

The HO-3, or **special homeowners policy** protects your home against all perils except those specifically excluded by the contract. It typically costs 10 to 15 percent more than the HO-1 policy.

Many insurance companies also offer guaranteed-re-

placement-cost policies, which go a step further than a standard HO-3. They offer to pay the full amount needed to replace your home and its contents, even if that exceeds the policy limit.

Despite its name, however, many companies set limits for this coverage, paying only up to 120 or 150 percent of the policy's face value. The limit for contents coverage is generally set at 75 percent of the home's replacement cost, as opposed to the standard 50 percent on other policies.

Some old homeowners policies pose a particularly significant risk, called **implied co-insurance**. This comes from the standard provision in most homeowners policies that the insurance company will not cover a portion of any loss greater than the proportion of the existing policy limit to the market value of the insured house.

Example: You have a house that would cost $200,000 to replace, but your policy has a $100,000 limit. Your insurer can maintain that you were purposefully taking on some of the risk of insurance—in this case, 50 percent of the risk. Assume you have a $150,000 loss, including contents and structure. While that would be fully covered if you were adequately insured, in this case the insurer may say the coverage is half that, or $75,000.

WARRANTY INSURANCE

Keeping up to date with your homeowners insurance needs is important because the insurance industry is changing constantly. And the advisory role that personal insurance agents used to play is disappearing. As a result, policy owners are left to battle insurance companies over coverage issues.

A recent illustration: With developers facing intense financial pressure in the current weak market, a growing number of new-home buyers demand **insured warranty programs** to pay for the cost of defective construction or unforeseen repairs to their new homes.

The policies usually cost several hundred dollars and cover major structural repairs for as many as 10 years and less severe problems for one or two years. But a series of lawsuits has raised concerns about whether owners of these policies have been getting their money's worth.

With growing frequency, particularly in cases where the home builder has gone out of business, the warranties are leading to disputes between the new homeowners and the insurance company over whether the coverage applies under the contract. Usually such disputes are heard by arbitrators.

In a 1991 case challenging the practices of **home-warranty companies**, a federal appeals court in Virginia required Denver-based Home Buyers Warranty, the nation's largest such company, to abide by an arbitrator's award of more than $200,000 to a policy owner. The company had sought to push the case into court.

The issue before the Fourth U.S. Circuit Court of Appeals centered on whether an arbitrator's award of $206,605 in damages to a homeowner in one such dispute was binding, or whether it could be appealed by the insurer through the courts. National Home Insurance had argued that either party had the option of appealing if dissatisfied by the arbitration award.

But in a 12-page opinion, the appeals court ruled that Home Buyers Warranty's contract language specifically requires binding arbitration.

This conclusion shouldn't have come as a surprise. In 1990, a Texas jury ordered Homeowners Warranty Corp., the nation's second largest home-warranty company, to pay $483,000 in damages to an policy owner whose house was falling apart because of a crack in the foundation.

Homeowners Warranty, which denied coverage, had assured the buyers that all homes insured under its program were inspected on a continuing basis during construction—a point that was contested at trial. Of the total jury award, $325,000 was for punitive damages intended to deter future wrongdoing. The two sides agreed to settle the case out of court for an undisclosed amount.

EXCLUSIONS AND OTHER RED FLAGS

An important point to remember when buying homeowners insurance: All types of coverage pose certain **exclusions**. Some people overlook these exceptions when reading through their policies later to find that their assets were not protected under their policies.

It is important to know when coverage does and does not apply. You should know the common restrictions of your policy before you purchase it.

Understand the concepts involved in **rating procedures**. Although there will be variations to contend with for different companies and different states, there will remain many similarities in approaches used. Having a basic understanding of the application of rules under the traditional rating procedures will make it easier for you to understand how rates are charged and adapt to future changes.

The **age of a home** is an important factor to insurance companies. Companies may charge up to 20 percent less to insure new homes than to insure older ones, which may be more susceptible to damage in storms and fires. Outdated building standards and old wiring can also make older homes riskier to insure.

MAKING CLAIMS

The process of making a claim on your homeowners insurance policy is referred to as the **adjustment process**. It is a negotiation, in which knowing your rights can be pivotal.

An insurance company has the right and the option to **investigate and settle** any lawsuit or claim against you. It also accepts an obligation to defend any lawsuit or claim—but if it pays the limit of its liability to settle a suit or claim it is no longer obligated to provide any further defense.

At the same time, it is also important to know the role you play in reporting a loss after a loss. Here are just a few effective ways to help ensure the best response to your claim:

- **Give immediate notice.** Promptly give notice to your insurance company or agent after a loss to covered property has occurred.

- **Make an inventory** list of the damaged personal property. Include all bills, receipts and related documents that justify the figures in the inventory.

- If there's been a loss by theft, be sure to **notify the police** as soon as possible.

- If loss or theft of a credit card or funds transfer card occurs, **notify the credit card or fund transfer card company.**

- Make an attempt to **protect the damaged property from further damage.** If repairs to the property are required, make the reasonable and necessary repairs as well as keep an accurate record of the repair expenses.

Read your policy and know the type of coverage you have. If you know the basics about your coverage, you're more likely to receive what you're entitled to. Here are some ways to double check your policy:

- **Verify the adjuster's estimate.** Don't accept the settlement until you get a written bid from a licensed contractor to make sure the adjuster's estimate is realistic.

But, before you bring in outside experts, check their qualifications.

- **Keep records.** Make copies of all information in connection with your claim. Hold onto everything the insurer gives you. You may also want to take notes of meetings and conversations with your agent, insurer, or claims adjuster.

- **Don't settle if the offer's unfair.** If you can't reach an agreement, contact your agent or the insurer's claim-department manager before making a settlement.

The way you handle the steps of this process can determine whether you come out of the loss financially whole.

If you think you need to sue your insurance company because you are dissatisfied over claim adjustments, you have to have complied with the policy provisions concerning the reporting of the loss, cooperating with the company in settling the loss, etc.

CONCLUSION

It is important to compare and contrast any large expense that you may have. Homeowners insurance is not an exception in order to find the coverage that individually suits you and obtain that coverage at premiums that you can afford.

It is important to compare not only insurance companies but the prices and level within each insurance company as well. If you follow the guidelines provided throughout this book, with some shopping around and

just a few adjustments you will be able to find coverage in a package that suits you and your homeowner needs.

INDEX